THE ELEMENTS OF
DYNAMIC SYMMETRY

THE ELEMENTS

OF

DYNAMIC SYMMETRY

BY

JAY HAMBIDGE

DOVER PUBLICATIONS, INC.

MINEOLA, NEW YORK

Reprinted from "The Diagonal," copyright, 1919,
1920 by Yale University Press.
Copyright © 1926, 1953 by Mrs. Jay Hambidge.
All rights reserved.

This Dover edition, first published in 1967, is an
unabridged and unaltered republication of the work
originally published by Brentano's, Inc. in 1926 and
reprinted in 1948 by the Yale University Press.

International Standard Book Number

ISBN-13: 978-0-486-21776-5
ISBN-10: 0-486-21776-0

Library of Congress Catalog Card Number: 66-30210

Manufactured in the United States by Courier Corporation
21776019 2015
www.doverpublications.com

PREFACE

THESE lessons have been taken from *The Diagonal*, a monthly magazine which Mr. Hambidge published while he was in Europe during the winter of 1919–20 at the request of students of dynamic symmetry, who were anxious to follow his research work in the museums there. Under the title of the "Elements" a lesson was given each month that the analyses of various objects might be understandable to the readers who were unfamiliar with the idea.

Except for a rearrangement in the sequence of the lessons no change has been made in the text. Fig. 2*a-e* of Lesson 1, Figs. 13 and 19 of Lesson 5, Fig. 28*c* of Lesson 6, Fig. 31*b* of Lesson 7 and Fig. 46*b* of Lesson 9 are the only new diagrams which have been added.

The book has fallen naturally into two parts: Part I contains the fundamental rectangles with their simple divisions based on the proportioning law found in nature; Part II the compound rectangles with their more subtle subdivisions, many of which were taken from or suggested by analysis of objects of Greek art. The elementary principles in Part I will give the student a working use of the idea. Much of Part II may be used for reference and for further study.

The simple mathematics necessary to an understanding of the elements of dynamic symmetry can be found in the book. The Definitions, selected from the Thirteen Books of Euclid's Elements and added at the end of the lessons, will explain most of the geometrical expressions used.

Dynamic symmetry is not a 'short cut' to artistic expression and mechanical devices such as 'triangles' and 'golden compasses,' logical substitutes for thinking, in a machine enslaved age, defeat its object. The actual process of studying and understanding the working of a natural design law, opens up a world of new ideas and frees the mind for real creation. Its very impersonal element encourages originality and precludes imitation. Knowledge of a basic law gives a feeling of sureness which enables the artist to put into realization dreams which otherwise would have been dissipated in uncertainty.

CONTENTS

INTRODUCTION

Synthesis and Analysis.—The Difference between Static and Dynamic
Symmetry.—Sources for the Study of Dynamic Symmetry.

THE basic principles underlying the greatest art so far produced in
the world may be found in the proportions of the human figure and
in the growing plant. These principles have been reduced to working
use and are being employed by a large number of leading artists,
designers, and teachers of design and manual art.

The principles of design to be found in the architecture of man
and of plants have been given the name "Dynamic Symmetry." This
symmetry is identical with that used by Greek masters in almost all
the art produced during the great classical period.

The synthetic use of these design principles is simple. The Greeks
probably used a string held in the two hands. The Harpedonaptae
or rope-stretchers of Egypt had no other instrument for orientating
and surveying or laying out temple plans. The recovery of these de-
sign principles by analysis is difficult, requiring special talent and
training, considerable mathematical ability, much patience and
sound aesthetic judgment. The analysis of the plan of a large build-
ing, such for example as the Parthenon, often is not so difficult as
the recovery of the plans of many minor design forms. Sometimes a
simple vase is most baffling, requiring days of intensive inspection
before the design theme becomes manifest.

To recover these themes of classic design it is necessary to use
arithmetical analysis. Geometrical analysis is misleading and inex-
act. Necessity compelled the old artists to use simple and under-
standable shapes to correlate the elements of their design fabrics. It
is evident that even the simplest pattern arrangements can become
very complicated as a design develops. A few lines, simple as a syn-
thetic evolution, may tax the utmost ingenuity to analyze.

The determination of the form principles in a specific example of
design means, in a sense, the elimination of the personal element.

With this element removed the residue represents merely the planning knowledge possessed by the artist. This residue is sometimes meagre and more or less meaningless; often it is rich in suggestion and positive design knowledge. Invariably the higher or more perfect the art, the richer is the remainder when the personal element is removed. Also the degree of planning knowledge is positive evidence of the conscious or unconscious use of a scheme in a work of art.

Saracenic, Mahomedan, Chinese, Japanese, Persian, Hindu, Assyrian, Coptic, Byzantine, and Gothic art analyses show unmistakably the conscious use of plan schemes and all belong to the same type. Greek and Egyptian art analyses show an unmistakable conscious use of plan schemes of another type. There is no question as to the relative merit of the two types. The latter is immeasurably superior to the former. This is made manifest as soon as the two types are tested by nature.

These plan schemes, which we find so abundantly in art, are nothing more than symmetry, using the word in the Greek sense of analogy; literally it signifies the relationship which the composing elements of form in design, or in an organism in nature, bear to the whole. In design it is the thing which governs the just balance of variety in unity.

The investigation of this impersonal aspect of art in relation to the symmetry of natural form was begun some twenty years ago. The results of the labor showed clearly that there were but two types of symmetry in nature which could be utilized in design. One of these types, because of its character, was termed "static," the other "dynamic." Possibly the former is but a special case of the latter, as a circle for example, is a special case of an ellipse. At any rate there is no question of the superiority of the dynamic over the static.

The static is the type which can be used both consciously and unconsciously in art. In fact no design is possible without symmetry. The savage decorating his canoe or paddle, his pottery or his blanket, uses static symmetry unconsciously. The crude drawings of the caveman disclose no design, consequently no symmetry.

As civilization advances the artist becomes more or less conscious of the necessity for symmetry or that quality in a work of art or craft which we recognize as design.

When we reach a period which is recognizable as an art epoch, where a people's character is shot through and through a great design fabric and the result stands as a national aesthetic expression, we find invariably, a highly sophisticated use of symmetry. But still it is almost always static.

Static symmetry, as the name implies, is a symmetry which has a sort of fixed entity or state. It is the orderly arrangement of units of form about a center or plane as in the crystal. A snow crystal furnishes a perfect example. It is apparent in cross sections of certain fruits. Diatoms and radiolaria supply other examples. It is the spontaneous type; *i.e.*, an artist or craftsman may use it unconsciously.

Static symmetry, as used by the Copts, Byzantines, Saracens, Mahomedans and the Gothic and Renaissance designers, was based upon the pattern properties of the regular two-dimensional figures such as the square and the equilateral triangle. The static symmetry used by the Greeks, before they obtained knowledge of dynamic symmetry, depended upon an area being divided into even multiple parts, such as a square and a half, three-quarters, one-quarter, one-third, two-thirds, etc.

The Tenea Apollo, a 6th century B. C. Greek statue, has a symmetry theme of three and two-thirds. This means that if a rectangle is made, the area of which consists of three squares and two-thirds of a square, it will be exactly the shape which will contain the projection of the statue. When we find that every member of the body is expressible in terms of this shape and that the theme produces a simple pattern form throughout we decide that this Apollo belongs to the static class.

It is well understood that the archaic Apollo statues of Greece closely followed an Egyptian prototype. A statue of Amenophis IV, of the 14th or 15th century B. C., which is such a prototype, discloses quite unmistakably a dynamic theme.

Diodorus Siculus, the Sicilian Greek historian, says that the early

Greeks obtained their sculptural knowledge from Egypt and tells the story of a certain Rhoecus, a great sculptor who learned his art in Egypt. He had two sons, Telecles and Theodorus, who like their father were sculptors. One of these sons worked at Samos, the other at Ephesus and between them they made a statue according to a prearranged plan. When the two parts of the figure were brought together they fitted exactly, so that the statue appeared the work of one man. Stories of this character suggest that the poet was possibly near the truth when he said:

> "From Egypt arts their progress made to Greece,
> Wrapt in the fable of the Golden Fleece."

Now that dynamic symmetry supplies a means by which we may closely inspect any design and classify it according to its symmetry theme, we see that the Tenea Apollo, though closely resembling the outward aspect of an Egyptian prototype, such as the statue of Amenophis IV, is in reality, as far as its symmetry is concerned, quite a different thing. The archaic Apollo sculptors of Greece apparently did not have knowledge of the Egyptian symmetry secret when the Tenea figure was made. When we find that the identical symmetry theme disclosed by the Tenea statue was used by Greeks to a limited extent, less than five per cent throughout the classical period, we conclude that this represents the work of a small number of designers who, apparently, did not know the dynamic scheme. Probably they did not belong to the craft guilds. After the decline of Athens and during the Hellenistic Age, we find this Tenea figure or static symmetry type used more and more until by the 1st century B. C. it is the only type observable; the dynamic type in all design entirely disappears at this date.

Curiously, there were but two peoples who did use dynamic symmetry, the Egyptians and the Greeks. It was developed by the former very early as an empiric or rule-of-thumb method of surveying. Possibly the date is as early as the first or second dynasty. Later it was taken over as a means of plan-making in architecture and design in general. The Egyptians seemed to attach some sort of ritualistic significance to the idea as it is found employed in this

sense in temple and tomb, particularly in the bas-reliefs which were used so plentifully to adorn these. It is also curious that the Hindus, about the 5th or 8th century B. C., possessed a slight knowledge of dynamic symmetry. A few of the dynamic shapes were actually worked out and appear in the Sulvasutras, literally "the rules of the cord," and were part of a sacrificial altar ritual. But to what extent it may have been used in Hindu art is not known, because examples containing its presence have disappeared.

The Greeks obtained knowledge of dynamic symmetry from the Egyptians some time during the 6th century B. C. It supplanted, probably rapidly, a sophisticated type of static symmetry then in general use. In Greece, as in India and in Egypt, the scheme was connected with altar ritual. Witness the Delian or Duplication of the Cube problem. The Greeks, however, soon far outstripped their Egyptian masters and within a few years after acquiring the knowledge, apparently made the astounding discovery that this symmetry was the symmetry of growth in man.

According to Vitruvius the Greeks learned symmetry from the human figure and were most particular in applying it to their works of art, especially to their temples. This, however, is not more reliable than other Vitruvian statements. The Roman architect had no knowledge of symmetry beyond a crude form of the static. He declared that the Greeks used a module to determine the symmetry of their temples and gives most elaborate instructions as to how the plans were developed. No Greek design has been found which agrees with the Vitruvian statements. In fact, the module would produce a grade of static symmetry which would have afforded much amusement to a Greek.

Dynamic symmetry in nature is the type of orderly arrangement of members of an organism such as we find in a shell or the adjustment of leaves on a plant. There is a great difference between this and the static type. The dynamic is a symmetry suggestive of life and movement.

Its great value to design lies in its power of transition or movement from one form to another in the system. It produces the only perfect

modulating process in any of the arts. This symmetry cannot be used unconsciously although many of its shapes are approximated by designers of great native ability whose sense of form is highly developed. It is the symmetry of man and of plants, and the phenomenon of our reaction to classic Greek art and to certain fine forms of other art is probably due to our subconscious feeling of the presence of the beautiful shapes of this symmetry.

Material for the study of dynamic symmetry is obtained from three sources: from Greek and Egyptian art, from the symmetry of man and of plants and from the five regular geometrical solids. We study Greek art for the purpose of learning how the greatest artists have used the rhythmic themes of area in actual masterpieces. The human skeleton shows us how nature employs these same themes in an organism. The five regular solids,* the cube, the tetrahedron, the octahedron, the icosahedron and the dodecahedron furnish abstract geometrical material for study. The skeleton, however, is the source *par excellence* for the artist.

The discovery of dynamic symmetry places the human skeleton in a new position in relation to art. Heretofore it has been but slightly considered—being regarded by artists chiefly as a framework supporting a muscular system of more or less value to them from the anatomical viewpoint. We must now regard this framework of bone as the chief source of the most vital principles of design.

It may not be inappropriate to mention here that the writer's interest lies entirely in the field of creative effort, and that research has been incidental only to his general aim. He was impelled to take up the study of symmetry because he could not entirely agree with the modern tendency to regard design as purely instinctive. As the trend of the individual and of society seems to be toward an advance from feeling to intelligence, from instinct to reason, so the art effort of man must lead to a like goal.

The world cannot always regard the artist as a mere medium who reacts blindly, unintelligently, to a productive yearning. There must come a time when instinct will work with, but be subservient to,

* See Definitions, p. 126.

intelligence. There have been such periods in the past, notably that of classic Greece.

The Greeks were by no means perfect but, for at least a generation in their history, they had a clear understanding of law and order and a passion for its enforcement. Life to them seemed a sublime game, but one meaningless without rules. Indeed, this is the distinction between the Greek and the barbarian.

The Christians struggled for a moral, the Greeks for an intellectual law. The two ideals must be united to secure the greatest good. As moral law without intellectual direction fails, ends in intolerance, so instinctive art without mental control is bound to fail, to end in incoherence. In art the control of reason means the rule of design. Without reason art becomes chaotic. Instinct and feeling must be directed by knowledge and judgment.

It is impossible to correlate our artistic efforts with the phenomena of life without knowledge of life's processes. Without mental control, instinct, or feeling compels the artist to follow nature as a slave a master. He can direct his artistic fate only by learning nature's ideal and going directly for that as a goal.

The present need is for an exposition of the application of dynamic symmetry to the problems of today. The indications are that we stand on the threshold of a design awakening. Returning consciousness is bound to be accompanied by dissatisfaction with the prevailing methods of appropriating the design efforts of the past.

When it is realized that symmetry provides the means of ordering and correlating our design ideas, to the end that intelligent expression may be given to our dreams, we shall no longer tolerate pilfering. Instead of period furniture and antique junk we shall demand design expressive of ourselves and our time. The oriental rug, the style house, the conscious and the artificial craft products, all echoes of other times and other peoples and sure evidence of design poverty, must give place to a healthy and natural expression of the aspirations of our own age.

THE ELEMENTS OF DYNAMIC SYMMETRY

SYMMETRY

THE DYNAMIC SYMMETRY OF THE PLANT

THE DYNAMIC SYMMETRY OF THE PLANT

The Summation Series.—How Dynamic Symmetry Was Discovered.—
The Logarithmic Spiral.—The Law of Phyllotaxis.—Explanation of
Its Application to Design.

It has long been known that a peculiar series of numbers is con-
nected with the phenomenon of the orderly distribution of the leaves
of plants. The series is: 1, 2, 3, 5, 8, 13, 21, 34, 55, 89, 144, etc. This
is called a summation series from the fact that each term is com-
posed of the sum of the two preceding terms. For those who may be
interested in the subject from the botanical standpoint reference is
made to the elaborate work of Professor A. H. Church of Oxford on
"Phyllotaxis in Relation to Mechanical Law." This series of num-
bers in reality represents the symmetry of the plant in the sense that
the word is used as "analogy," which is its Greek meaning. From this
series we obtain the entire structure of dynamic symmetry, which
applies not only to the architecture of the plant but to the architec-
ture of man.

This summation series of numbers, because of its character, rep-
resents a ratio, *i.e.*, it is a geometrical progression. This ratio may be
obtained by dividing one term into another, such as 34 into 55. The
series does not represent the phenomenon exactly but only so far
as it is representable by whole numbers. A much closer representa-
tion would be obtained by a substitute series such as 118, 191, 309,
500, 809, 1309, 2118, 3427, 5545, 8972, 14517, etc. One term of this
series divided into the other equals 1.6180, which is the ratio neces-
sary to explain the symmetry of the plant design system.

The operation of the law of leaf distribution and its connection
with the summation series of numbers is explained by Professor
Church, who uses as illustration the disk of the sunflower.

"The most perfect examples of phyllotaxis easily obtainable are

3

afforded by the common sunflower, so frequently selected as a typical Angiosperm, both in anatomical and physiological observations, owing to the fact that it exhibits, *par excellence*, what is regarded as a normal structure little modified by specialization for any peculiar environment. Not only is the sunflower a leading type of the Compositae which holds the highest position among Angiosperm families, but amongst this family it flourishes in the best stations, in which sunlight, air, and water supply are perhaps at an optimum for modern vegetation. The very fact that it is as near an approximation to the typical Angiosperm as can perhaps be obtained, suggests that the phenomena of growth exhibited by it will also be normal, and from the time of Braun to that of Schwendener it has afforded a classical example of spiral phyllotaxis."

The sunflower heads "admit of ready observation. By taking a head in which the last flowers are withering, and clearing away the corolla tubes, the developing ovaries are seen to mark out rhomboidal facets, and when the fruits are ripened, and have been shed, the subtending bracts still form rhomboidal sockets. These sockets, with or without fruit, form a series of intersecting curves identical with those of the pine cone, only reduced to a horizontal plane.

"A fairly large head, 5–6 inches in diameter in the fruiting condition, will show exactly 55 long curves crossing 89 shorter ones. A head slightly smaller, 3–5 inches across the disk, exactly 34 long and 55 short; very large 11-inch heads give 89 long and 144 short; the smallest tertiary heads reduce to 21–34, and ultimately 13–21 may be found; but these, being developed late in the season, are frequently distorted and do not set fruit well.

"A record head grown at Oxford in 1899 measured 22 inches in diameter, and, though it was not counted, there is every reason to believe that its curves belonged to a still higher series, 144–233. The sunflower is thus limited in its inflorescence to certain set patterns, according to the strength of the inflorescence axis, *e.g.*, 13/21, 21/34, 34/55, 89/144. These were first observed by Braun (1835), and translated into terms of the Schimper-Braun series they would correspond to divergences of 13/34, 21/55, 34/89, 55/144, and 89/233,

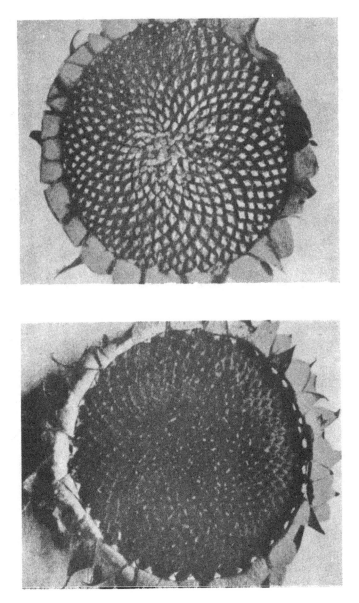

Sunflower heads used by Professor Church to exhibit the phyllotaxis
phenomena

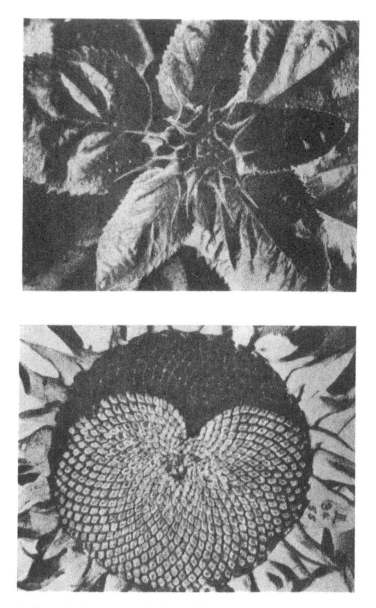

Sunflower heads used by Professor Church to exhibit the phyllotaxis phenomena

respectively. Under normal circumstances of growth, the ratio of the curves is practically constant. (Cf. Weisse. Out of 140 plants 6 only were anomalous, the error being thus only 4 per cent.)"

The ratio 1.6180, when reduced to a rectangular area makes a rectangle which has been given the name by the writer, of the "rectangle of the whirling squares." For a description of a root-five rectangle and the rectangle of the whirling squares, see Lesson 2, Part I.

To the end that the artist may understand the essential idea connected with the form rhythms observable in plant architecture and apply it to his immediate needs, it is advisable to digress at this point and explain how observation of this form rhythm led to the discovery of dynamic symmetry. Many years ago the writer became convinced that the spiral curve found in plant growth, which Professor Church describes in his work on the law of leaf distribution, and that of the curve of the shell, were identical, and must be the equiangular or logarithmic spiral curve of mathematics. It will not be necessary for the present purpose to enumerate all the evidence which justifies this assumption. For the benefit of those who may care to pursue the subject further, reference is made to a paper by the Rev. H. Moseley, "On the Geometrical Forms of Turbinated and Discoid Shell" (Phil. Trans. pp. 351–370, 1838) * and to the able and clear treatment of the spiral by D'Arcy W. Thompson. ("Growth and Form," Cambridge, Eng., 1917.)

Being convinced that the spiral was indeed the mathematical curve mentioned, the writer saw that, because of a certain property which it possessed, this spiral could be reduced from a curve form to one composed of straight lines and thereby be used by the artist to solve certain problems of composition and connect design closely with nature.

This property of the curve is: between any three radii vectors of the curve, equal angular distance apart, the middle one is a mean

*Philosophical Transactions of the Royal Society, London, Vol. 128, 1838, pp. 351–370.

proportional between the other two. The drawing, Fig. I, explains this.

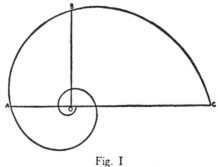

Fig. I
The Logarithmic or Equiangular Spiral

O is the pole or eye of the curve and the lines OA, OB, OC, are radii vectors equal angular distance apart. In this case the angle is a right angle. According to the definition the line OB is a mean proportional between the other two, *i.e.*, OA and OC.

This means, speaking in terms of area, that the line OB is the side of a square equal in area to a rectangle the end and side of which are the lines OA and OC. It necessarily follows, therefore, that if three lines stand in this relationship they constitute the essentials of a right angle. This is shown in Fig. II.

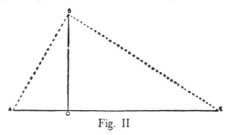

Fig. II

The line OB is a mean proportional between the lines OA and OC and the shape ABC is a triangle, right-angled at B, and the line AC is the hypotenuse.

One of the earliest geometrical facts determined by the ancient Greeks was that in a right angled triangle a line drawn from the

intersection of the two sides to meet the hypotenuse at right angles was a mean proportional between the segments of the hypotenuse. Simply stated, this means that three lines situated like the three radii vectors mentioned constitute three terms of a continued proportion; OA is to OB as OB is to OC.

The relation between these lines could be stated arithmetically as a ratio, this following from the fact that lines in continued proportion form a geometrical progression.

If we assume, for example, that the ratio is 2 and the length of the line OA is two units, then the line OB would be four units and the line OC eight units. 2, 4, and 8 constitute three terms of a simple proportion with a ratio of 2 and according to the rule of three, the square of the mean is equal to the product of the extremes. In this case 4 is the mean and 2 and 8 are the extremes. 4 multiplied by itself, or squared, equals 2 multiplied by 8.

The mean is the side of a square equal in area to the area of a rectangle made by the extremes or 2 as end and 8 as side.

Fig. III

But the line OB may be produced through the pole O of the spiral until it touches the curve at the point D and DAB will be a right angle and there will exist four lines in continued proportion, OD, OA, OB and OC. Also, the curve cuts the vector lines at E and F, etc., and other right angles are created. In short, the curve may be reduced from a curve to a rectangular spiral, and, as in the curve, the converging right angles wrap themselves to infinity around the pole. This particular curve never reaches the pole, it goes on forever.

Fig. IV

The essential point is that this simple construction enables the designer to introduce the law of proportion into any type of composition and that, too, in much the same way as it appears in the plant and in the shell. The operation by which this is accomplished is the drawing of a diagonal to a rectangle and a line from one corner cutting this diagonal at right angles, Fig. V.

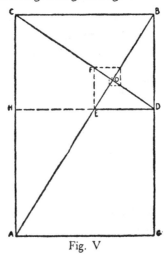

Fig. V

Fig. V is any rectangle and AB is a diagonal. The line CD, drawn from the corner C, cuts the diagonal AB at right angles at O. It is apparent that the angular spiral formed by the lines AC, CB, BD, DE and EF is identical with the angular spiral derived from the shell and from the plant.

Having established a condition of proportion within the area of a rectangle it becomes obvious that the line CD must perform some important function.

Artists are well acquainted with at least one property of the diagonal to a rectangle. It is well known, for example, that any shape drawn within the area of a rectangle whose diagonal is common to the diagonal of the containing area is a similar shape to the whole. This geometrical fact is utilized in the arts, especially the reproductive arts, for the purpose of determining similar shapes on a larger or smaller scale. This, however, is about as far as modern artistic knowledge of proportion extends. The value of the line CD is unknown to modern art. That the value of this line was known at one time in the history of art and its power appreciated is abundantly proven by dynamic analysis of classical Greek design. This line CD determines the reciprocal of a rectangular shape and is itself the diagonal of that shape. Following the construction we appreciate the fact that, in a rectangular area, the diagonal of a reciprocal cuts the diagonal of the whole at right angles. (See Lesson 5.)

The line HD, Fig. V, which is drawn parallel to the ends AG or CB, fixes the area of the reciprocal of the shape AB. With this notion of a reciprocal in mind it is apparent that the fatter or squatter the rectangle the larger will be the area of the reciprocal.

For example, if instead of the rectangle AB of Fig. V, one is constructed which much more closely approaches the shape of a square, the area of the reciprocal, because it is a similar shape to the whole, will also much more closely approach the shape of a square.

The breadth of the reciprocal increases with the breadth of the parent form until it coincides with it as a square; or it decreases until both become a straight line. Obviously, also, there must be rectangles such that the reciprocal is some even multiple of the parent form, such as 1/2, 1/3, 1/4, 1/5 and so on.

Perception of this fact led the writer to discover the root rectangles. It was found that a rectangle whose reciprocal equalled one-half the whole was a root-two rectangle; 1/3 a root-three, 1/4 a root-four and 1/5 a root-five rectangle and so on. When the root-five rectangle was defined and its commensurable area examined it was found that this

shape was connected in a curious manner with the phenomena of leaf distribution.

As has been explained, the ratio produced by the summation series of numbers, which so persistently appears in the rhythmic arrangements of leaves and seeds in vegetable growth, is 1.6180. When a rectangle was made wherein the relationship between the end and side was the ratio 1.6180 it was found that the end of the reciprocal of this area equalled .618.

The side of a root-five rectangle, arithmetically expressed, is 2.2360 or the square root of five. If the ratio 1.6180 is subtracted from 2.2360 the remainder is .6180. The area of a root-five rectangle, therefore, is equal to a 1.6180 rectangle plus its reciprocal.

The 1.6180 rectangle, because the end of its reciprocal equals .618, is a rectangle such that its *continued* reciprocals cut off squares and these squares form a spiral around a pole of the rectangle. This pole, of course, is the point where the diagonal of a reciprocal and a diagonal of the whole cross each other. Because of this property this shape was given the name "the rectangle of the whirling squares." (See Lesson 4.)

The importance to design of the curve-cross pattern arrangements found in the leaf distribution phenomena lies in the fact that the normal scheme represented by the sunflower disk is clearly connected with commensurability of area. And, because an area may represent the projection of a solid, the measurableness of the two-dimensional plan is also that of the three-dimensional plant example.

The dynamic rectangles, which we obtain from the growth phenomena, are distinguished by this property of area measurableness. It is this characteristic which lies at the base of the rhythmic theme conception and gives the dynamic scheme its greatest design value.

Because of the persistence of the normal ratios of phyllotaxis the conclusion is inevitable that the measurable area themes possess life and all the qualities that go with it, while areas which do not have this peculiar property do not have life. They are "static" or dead areas, at least as far as design is concerned. If the testimony of Greek

art has value this would seem to be so. We know that one character-istic of Greek design is just this life-suggesting quality. Many have noticed it. We know also that Roman art, by comparison, is lifeless. Many have noticed and commented upon this fact. Indeed, we need not go further than Roman sculpture, with its surface common-placeness and stodgy, uninspired design quality, to see how true this is.

It is recognized that the substitute summation series, which has been suggested to take the place of the whole number series used by botanists to express the curve-cross phenomena of distribution, can have little if any value in checking an actual plant structure. The fractions necessary to make the ratio 1.618 complete for the system are so small that their presence in a specimen could not be noted.

We are using the phyllotaxis phenomena for purposes of design and are not so much interested in botanical research. The plant structure is so delicate and the skeletal residue so slight, after an average plant withers, that direct observation for commensurable area themes is out of the question. We may leave the field to the botanist and let him retain the conventional series of whole num-bers.

To the artist, however, the numbers of the substitute series, 118, 191, 309, 500, 809, 1309, 2118, 3427, 5545, etc., are of much interest, because they not only furnish the exact ratio of 1.6180, but each member of the series is an actual ratio of the dynamic commensu-rable area scheme and is found abundantly not only in the human skeleton, but throughout classic Greek design.

Nature provides many plant examples wherein the curve-cross system varies from the normal whole number series. These less common arrangements of curve-cross pattern form are mentioned by Church in the following terms:

"When the type of normal asymmetrical phyllotaxis is thus com-pletely isolated as consisting of systems mapped out by log spiral curves in the ratio-series of Braun and Fibonacci, 2, 3, 5, 8, etc.; and the type of normal symmetrical phyllotaxis is equally clearly de-limited as a secondary construction, physiologically independent of

the ratio-series, though connected with it phylogenetically, the greatest interest attaches to all other phyllotaxis phenomena, which, though less common, may throw light on the causes which tend to induce symmetry, before postulating, as a last resource, some hypothetical inherent tendency in the protoplasm itself.

"These may be included under two series: first, the multijugate systems of Bravais, and, second, systems in which the parastichy ratios belong to series other than that of Braun and Fibonacci, e.g., the 3, 4, 7, 11————, 4, 5, 9, 14————, or still higher series (these latter Church classifies as belonging to anomalous series. It will be noticed that they also are summation series).

"The term *multijugate* was applied by the brothers Bravais to types of phyllotaxis in which the numbers expressing the parastichy ratios are divisible by a common factor; so that 2 (13/21) = (26/42), a bijugate system; while 3 (13/21) = (39/63) would be a trijugate one."

The fact that they may occur in the plant (*i.e.*, multijugate systems) which has already been found to exhibit normal phyllotaxis phenomena most completely, lends additional interest to these constructions. Thus, out of a batch of heads, collected at haphazard by E. G. Broome, two were bijugate, 26/42 (read 26 crossing 42) and 42/68, respectively; the others were quite normal; while out of a total crop of 130 cones on a plant of *pinus pumilis* one cone only was 6/10/16—see illustration—the rest being normal, or 5/8/13, "Phyllotaxis in Relation to Mechanical Law."

These so-called multijugate types are interesting, particularly when a specimen shows a variation from the normal scheme to one of multiples of that ratio by 2 or 3. Using the suggested substitute series and considering the commensurable area themes of dynamic symmetry, the bijugate scheme as 26 crossing 42 is 1309 crossing 2118 wherein both members are multiplied by 2.

The trijugate arrangement, 39 crossing 63, becomes 1309 and 2118 multiplied by three, and the schemes would be, as measurable area arrangements, 2618, 4236, 3927, 6354, respectively. A 6/10/16 plan,

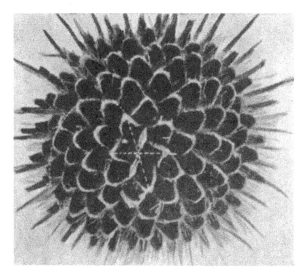

Pinus pumilis, bijugate cone of type 6/10/16

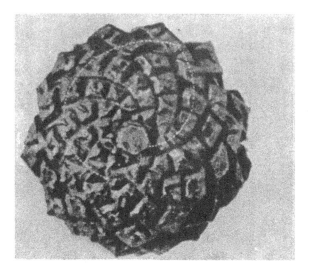

Dipsacus pilosus, L. Inflorescence of the type 10/16

as a commensurable area theme of dynamic symmetry would be .618, 1. and 1.618.

This leads us to consider somewhat in detail the substitute summation series. Its properties are curiously interesting. Any two members of the series added equal a third member.

Every term divided into its successor equals the ratio 1.618.

Every term divided into a third term equals 1.618 squared or 2.618.

Every term divided into a fourth term equals 1.618 cubed or 4.236.

Every term divided into a fifth term equals 1.618 raised to the 4th power or 6.854.

Every term divided into a sixth term equals 1.618 raised to the 5th power or 11.090, etc.

Powers of 1.618 divided by 2 produce the summation series of numbers.

$$\frac{2618}{2} \text{ equals } 1309 \qquad \frac{17944}{2} \text{ equals } 8972$$

$$\frac{4236}{2} \text{ equals } 2118 \qquad \frac{29034}{2} \text{ equals } 14517$$

$$\frac{6854}{2} \text{ equals } 3427 \qquad \frac{46978}{2} \text{ equals } 23489, \text{ etc.}$$

$$\frac{11090}{2} \text{ equals } 5545$$

1.618 divided by 2 equals .809.

Unity divided by 2 equals .5.

$$.618 \text{ squared equals } .382 \qquad \frac{.618}{2} \text{ equals } .309$$

$$.618 \text{ cubed equals } .236 \qquad \frac{.382}{2} \text{ equals } .191$$

$$.618 \text{ 4th. power equals } .146, \text{ etc.} \qquad \frac{.236}{2} \text{ equals } .118, \text{ etc.}$$

The square of 1.618 equals 1.618 plus 1. or 2.618.

.618 plus .618 squared equals 1.

The student will recognize all these numbers as ratios representing the dynamic measurable areas. The few relationships mentioned are merely suggestive; an extraordinary number of curiously fascinating interdependencies may be worked out of this summation series. When the series is charted as the expansion of a scheme of squares and subdivisions of squares it appears as in Fig. VI.

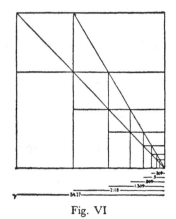

Fig. VI

It will be clear to those who have studied dynamic symmetry that the basic pattern plan of leaf arrangement is but one phase of an architectural scheme connected with the phenomena of growth in general. Fortunately, as artists, we need not depend upon plant forms for detailed knowledge of the mysteries of dynamic form. The human skeleton furnishes all that the plant does and more. It is practically impossible to measure the withered plant structure. Comparatively, the bone network of man's frame is more stable than the skeleton of the plant, and, what is of much greater artistic importance, man is and always has been recognized as the most perfect type of design in nature.

It is felt that the foregoing rough outline of the dynamic symmetry of the plant is all that is necessary to show the artist that the dynamic scheme has a general basis in plant growth.

PART I

SIMPLE RECTANGLES

THE ELEMENTS OF DYNAMIC SYMMETRY

LESSON 1

The Square (1 or Unity).

THESE lessons will deal entirely with the fundamental principles of symmetry as they are found in nature and in Greek art; no attempt will be made to show their application to specific examples of nature or of art.

THE BASES OF DYNAMIC SYMMETRY

 The Square and its diagonal and the square and the diagonal to its half

a b

The square and its diagonal furnish the series of root rectangles. The square and the diagonal to its half furnish the series of remarkable shapes which constitute the architectural plan of the plant and the human figure.

The most distinctive shape which we derive from the architecture of the plant and the human figure, is a rectangle which has been given the name "root-five." It is so called because the relationship between the end and side is as one to the square root of five, 1.:2.2360 plus.*

As a length unit the end cannot be divided into the side of a root-five rectangle, because the square root of five is a never-ending fraction. We naturally think of such a relationship as irrational. The

*N. B.—Ciphers, plus and minus signs added to ratios, and fractions beyond the actual figures of the ratio will hereafter be omitted to avoid repetition and confusion.

Greeks, however, said that such lines were not irrational, because they were commensurable or measurable in square. This is really the great secret of Greek design. In understanding this measurableness of area instead of line the Greek artists had command of an infinity of beautiful shapes which modern artists are unable to use. The relationship between the end and side of a root-five rectangle is a relationship of area and not line, because as lengths one cannot be divided into the other, but the square constructed on the end of a root-five rectangle is exactly one-fifth the area of the square constructed on the side. The areas of rectangles which have this measurable relationship between end and side possess a natural property that enables us to divide them into many smaller shapes which are also measurable parts of the whole.

A simple method for constructing all the root rectangles is shown in Fig. 1.*

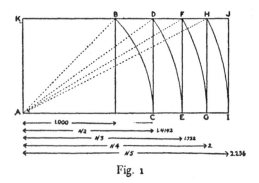

Fig. 1

In Fig. 1, AB is a square whose side is assumed to be unity, or 1. Since the diagonal of a square whose side is unity equals the square root of two, the diagonal AB equals the square root of two. With A as center and AB as radius describe the arc of a circle, BC. The line AC equals AB, or the square root of two. AD is therefore a root-two rectangle. Numerically the line KA equals unity or 1. and the line AC equals the square root of two, or 1.4142.

* 1 or unity should be considered as meaning a square. The number 2 means two squares, 3, three squares and so on.

The diagonal of the root-two rectangle, AD, equals the square root of three. By the same process the line AE is made equal to AD, or the square root of three. AF is therefore a root-three rectangle. Numerically its height, KA, equals unity or 1.; its length, AE, equals the square root of three, or 1.732.

The diagonal of the root-three rectangle, AF, equals the square root of four. By the same process the line AG is made equal to AF or the square root of four. AH is therefore a root-four rectangle. Numerically its height, KA, equals unity or 1.; its length, AG, equals the square root of four, or 2. The root-four rectangle is thus seen to be composed of two squares, since its length equals twice its height.

The diagonal of the root-four rectangle, AH, equals the square root of five. By the same process the line AI is made equal to AH, or the square root of five. AJ is therefore a root-five rectangle. Numerically its height, KA, equals unity or 1.; its length, AI, equals the square root of five, or 2.236.

This process can be carried on to infinity. For practical purposes no rectangles beyond the root-five rectangle need be considered. In Greek art a rectangle higher than root-five is seldom found. When one does appear it is almost invariably a compound area composed of two smaller rectangles added together.

In any of the root rectangles a square on the longer side is an even multiple of a square on the shorter side. Thus a square constructed on the line AC has twice the area of the square on KA; the square on AE has three times the area of the square on KA; the square on AG has four times the area of the square on KA; the square on AI has five times the area of the square on KA. This is demonstrated graphically in the following diagrams, Fig. 2.

The linear proportions $1, \sqrt{2}, \sqrt{3}, \sqrt{4}, \sqrt{5}$, etc., are based on the proportions of square areas derived by diagonals from a generating square.*

The linear proportions $1, \sqrt{2}, \sqrt{3}, \sqrt{4}, \sqrt{5}$, are geometrically established as in Fig. 2.

* N. B.—The signs $\sqrt{2}, \sqrt{3}, \sqrt{4}, \sqrt{5}$, stand for root-two, root-three, etc.

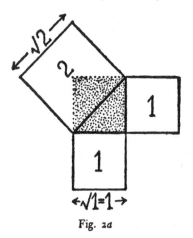

Fig. 2*a*

In Fig. 2*a* this unit square is indicated by shading. Its diagonal divides it into two right-angled triangles, one of which is marked by heavy lines. The 47th proposition of the first book of Euclid proves that the square on the hypotenuse of a right-angled triangle equals the sum of the squares on the other two sides. Since the area of each of these two squares is 1, the area of the square on the hypotenuse is 2; and its side (or the diagonal of the unit square) equals $\sqrt{2}$. The side of the unit square is $\sqrt{1}$, which is equal to 1. Thus the linear proportion 1: $\sqrt{2}$ has been established.

In Fig. 2*b* the diagonal of the unit square is used as the base of a rectangle with sides of the lengths 1 and $\sqrt{2}$. This is called a root-two rectangle. Its diagonal divides it into two right-angled triangles, one of which is marked by heavy lines. The squares on the two shorter sides of this triangle are equal to 1 and 2 respectively. Therefore the square on its hypotenuse equals 1 + 2, or 3; and the side of this square (or the diagonal of the root-two rectangle) equals $\sqrt{3}$. Thus the linear proportion 1: $\sqrt{3}$ has been established.

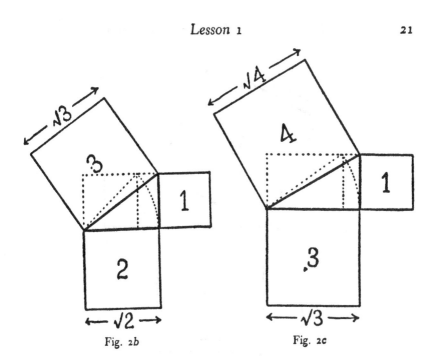

Fig. 2b Fig. 2c

In Fig. 2c the diagonal of the root-two rectangle is used to construct a rectangle with sides of the lengths 1 and $\sqrt{3}$. This is called a root-three rectangle. Its diagonal makes, with the two adjacent sides of the rectangle a right-angled triangle, which is marked by heavy lines. The squares on the two shorter sides of this triangle are equal to 1 and 3 respectively. The square on its hypotenuse equals $1 + 3$, or 4; and the side of this square (or the diagonal of the root-three rectangle) equals $\sqrt{4}$. Thus the linear proportion $1 : \sqrt{4}$ has been established.

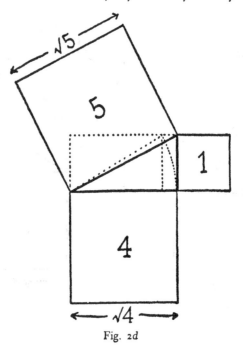

Fig. 2*d*

In Fig. 2*d* the diagonal of the root-three rectangle is used as the base of a rectangle with sides of the lengths 1 and $\sqrt{4}$. This is called a root-four rectangle. Its diagonal makes with the two adjacent sides of the rectangle a triangle, which is marked by heavy lines. The squares on the two shorter sides of this triangle are equal to 1 and 4 respectively. The square on its hypotenuse equals $1 + 4$, or 5, and the side of this square (or the diagonal of the root-four rectangle) equals $\sqrt{5}$. Thus the linear proportion $1 : \sqrt{5}$ has been established.

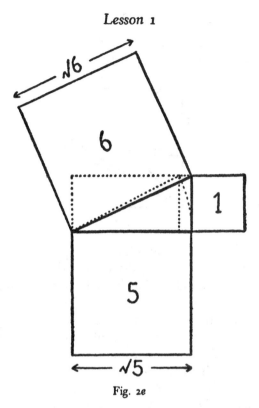

Fig. 2e

In Fig. 2e the diagonal of a root-four rectangle is used to construct a rectangle with sides of the lengths 1 and $\sqrt{5}$. This is called a root-five rectangle. Its diagonal makes, with the two adjacent sides of the rectangle, a triangle. The squares on the two shorter sides of this triangle are equal to 1 and 5 respectively. The square on its hypotenuse equals $1 + 5$, or 6, and the side of this square (or the diagonal of the root-five rectangle) equals $\sqrt{6}$. Thus the linear proportion $1 : \sqrt{6}$ has been established. This process can be carried on to infinity.

The root rectangles are constructed within a square by the following simple method:

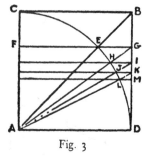

Fig. 3

In Fig. 3, AB is a square and CED is a quadrant arc of a circle, the radius of which is AD. The diagonal of the square AB cuts the quadrant arc at E, and FG is a line through the point E drawn parallel to AD. AG is a root-two rectangle within the square AB.

The diagonal of the root-two rectangle AG cuts the quadrant arc at H. A line through the point H similar to the line through E establishes the root-three rectangle AI.

The diagonal of the root-three rectangle AI cuts the quadrant arc at J. The area AK is a root-four rectangle.

The diagonal of the root-four rectangle AK cuts the quadrant arc at L. The area AM is a root-five rectangle, and so on.

There are many other methods for the construction of root rectangles, both outside and inside a square, but, in the writer's opinion the ones described are the simplest.

LESSON 2

The Rectangle of the Whirling Squares (1.618) and the Root-Five Rectangle (2.236).

In the preceding lesson we learned the evolution of the root rectangles from the diagonal of a square. We shall now consider the important rectangle derived from the diagonal to half a square called the "rectangle of the whirling squares," numerically expressed as 1.618.*

Because of the close relationship of the 1.618 to the root-five rectangle we shall have to consider the two together before taking the root-five in the logical sequence of its development from the square.

The rectangle of the whirling squares:

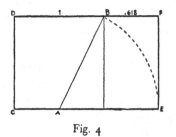

Fig. 4

Draw a square as CB in Fig. 4. Bisect one side as at A. Draw the line AB and make AE equal to AB. Complete the rectangle by drawing the lines BF, FE. This rectangle, DE, is the rectangle of the whirling squares. It is composed of the square CB and the rectangle BE.

* The name "whirling squares" will be explained in Lesson 4.

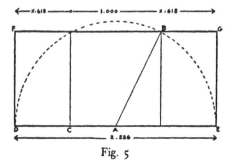

Fig. 5

The construction of a root-five rectangle is simple. Draw a square as CB in the diagram Fig. 5, and bisect one side as at A. Draw a line from A to B and use this line as a radius to describe the semicircle DBE. AE and AD are equal to AB, or the line DE is twice the length of the line AB. Complete the rectangle by drawing the lines DF, FG and GE. It will be noticed that the rectangle FE is composed of the square CB and two rectangles FC and BE. This is the root-five rectangle and its end to side relationship is as one to the square root of five, 1:2.236; the number 2.236 being the square root of five. Multiplied by itself this number equals 5.

The root-five rectangle produces a great number of other shapes which are measurable in area with themselves and with the parent shape. The principal one of these is the 1.618 or that which is made by cutting a line in, what Plato called "the section." * The relationship of this rectangle to the root-five rectangle is shown by its construction. It is apparent that this shape is equal to the root-five rectangle minus one of the small rectangles FC or BE of Fig. 5.

The construction of the shapes of vegetable and animal architecture is simple and if we wished to begin using them in design little more would be necessary. Unfortunately we cannot afford to wait to discover all the wonderful properties possessed by these simple shapes by practically employing them in our design problems. Time is too short and our needs too great. But, fortunately, we have the use of a tool which the Greek artists did not possess. That implement

* See "Section" in Glossary.

is arithmetic. By the use of a little adding, multiplying, dividing and subtracting, we may expedite our progress enormously. This will be apparent if we consider the square of the root-five rectangle as representing one or unity; this may be 1. or 10. or 100. or 1000, but it will always be a square as an area of sides of equal length. Regarded thus it will be apparent that the area of any rectangle may be composed of one or more squares plus some fractional part of a square. The square root of five is 2.236; if one is subtracted from this number the result will be 1.236. In this case 1.236 represents the two small rectangles on either side of the square, .618 plus .618 equals 1.236. If this number is divided by two, the result is .618. This number represents each one of the two small rectangles. We now see that the area of the root-five shape may be considered as 1. plus .618 plus .618. Also it is now apparent that the area of the rectangle of the whirling squares may be considered numerically as 1. plus .618.

It was stated in the first lesson that the relationship between the areas of the squares described on the end and side of a root-five rectangle was as one to five. The square described on the side of a whirling square rectangle is equal in area to the square described on the end, plus the area of the rectangle itself.

LESSON 3

The Application of Areas.

For the purpose of dividing up the areas of rectangles so that the divisions would be recognizable, the Greeks had recourse to a simple but ingenious method which is called the "application of areas." This idea was used by them both in science and in art. For a description of the process as used in science, see any standard work on the history of Greek geometry.

Classic design furnishes abundant examples of its use in art. The process in design may be illustrated by either of the rectangles described in the preceding lesson.

If, to a rectangle of the whirling squares, we apply a square on the end of that shape, the operation is equivalent to subtracting 1. from 1.618. A square on the end applied to the area of a whirling square rectangle leaves as a remainder a .618 area. If a square on the end of a rectangle is applied to its side, however, the operation is not so simple unless we use the Greek method. This process is shown in Fig. 6.

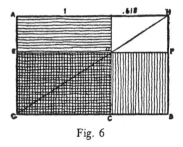

Fig. 6

To the rectangle AB the square AC is applied on the end.

28

To apply this same square to a side as GB, we must first draw a diagonal to the whole shape as GH. This diagonal cuts the side of the square AC at D. Through the point D we draw the line EF. The area EB is equal to the area of the square AC. (For proof, see similarity of figure, Lesson 7, Fig. 35b.)

This process applies to any rectangular area whatever which may be applied either to the end or the side of a rectangle. It will be noticed that the square on the end of a rectangle when applied to a side changes its shape, *i.e.*, it is no longer a square, though equal in area to the area of a specific square. It is clear that now it is composed of a square plus some other area which may be composed of either a square or squares or some fractional part of a square.

LESSON 4

The Reciprocal.

A PROCESS connected with the science of plan-making which was thoroughly understood by the Greeks, was that of determining the reciprocal of a rectangle. This conception of a reciprocal of a shape is most important. Briefly, the reciprocal of a rectangle is a figure similar in shape to the major rectangle but smaller in size. The end of the major rectangle becomes the side of the reciprocal. Greek art shows us several simple methods for determining reciprocals, but they all depend upon the fact that the diagonal of a reciprocal cuts the diagonal of the major shape at right angles. Fig. 7 is a rectangle of the whirling squares.

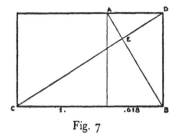

Fig. 7

AB is a reciprocal to the shape CD and the diagonals CD and AB cut each other at right angles at E. The rectangle AB is a similar shape to the whole, *i.e.*, the area AB is exactly like the area CD, the difference being one of size only. The line BD, which is the end of the larger rectangle, is the side of the smaller one. The name, the rectangle of the whirling squares, may now be explained.

Because of the fact of similarity, the reciprocal of this shape, Fig. 7, is also a whirling square rectangle and the area CA, *i.e.*, the area

in excess of the area AB, is a square and if we define the continued
reciprocals of this specific shape, the result would appear as Fig. 8.

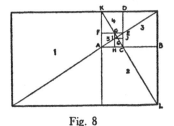

Fig. 8

A diagonal of the whole and a diagonal of a reciprocal, enable us
to draw readily the continued reciprocals. The area KB is a reciprocal
of the area KL and the area KC is a reciprocal of the area KB, etc.
These areas are all similar shapes. The numbered areas, 1, 2, 3, 4, 5,
etc., are all squares. A rectangle of the whirling squares is so called
because its continued reciprocals cut off squares and these squares
arrange themselves in the form of a spiral whirling to infinity around
a pole or eye. The appearance in nature of this rectangle is explained
in the lesson on the phenomenon of leaf arrangement.

The arithmetical statement of the reciprocal may now be con-
sidered. If unity or 1. represents the area of a square, then, in a
whirling square rectangle, the fraction .618 must represent the re-
ciprocal and the area .618 is also a whirling square rectangle. We
obtain the reciprocal of any number by dividing that number into
unity, which is equivalent to dividing the side into the end. 1.618
divided into 1. equals .618. The square root of five divided into unity,
2.236 into 1., equals .4472. The area represented by .618 is a whirling
square rectangle, and that by .4472 is a root-five rectangle. As far
as shape is concerned a root-five rectangle, numerically, may be
2.236 or .4472; this also applies to a rectangle of the whirling squares
which may be 1.618 or .618. Any rectangle may be arithmetically
expressed in the same manner.

It will be noticed that a root-five rectangle may be considered as
composed of a square plus two whirling square rectangles, or as a

square plus two reciprocals of that shape. It may also be considered as two whirling square rectangles overlapping each other to the extent of a square, Fig. 9.

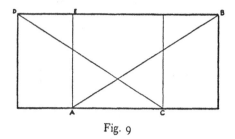

Fig. 9

DC and AB are whirling square rectangles and they overlap to the extent of the square EC. Also, EC is a square and DA and CB, are each whirling square rectangles. Each of these shapes, DA and CB, are reciprocals of the areas DC and AB.

LESSON 5

The Diagonal.

Fig. 10

FOR purposes of design the most important element of a rectangle is its diagonal. The area of the square upon the diagonal of any rectangle is equal to the areas of a square upon its end and a square upon its side. This important fact was supposedly discovered by the early Greeks. It is the 47th proposition of the first book of Euclid and has been picturesquely described by Kepler as "a measure of gold." (See Lesson 1.)

The element of a rectangle second in importance to the diagonal, is the diagonal of a reciprocal, as shown in Fig. 11.

Fig. 11

The diagonal of the reciprocal of a rectangle cuts the diagonal of the whole at right angles.

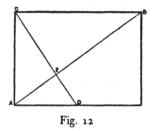

Fig. 12

AB of Fig. 12, is the diagonal of a root-two rectangle and CD is the diagonal of its reciprocal. E is the right-angled intersection of the two lines.

The reciprocal of a rectangle may be established in various ways by simple geometrical construction:

(1) By a perpendicular to the diagonal, Fig. 13.

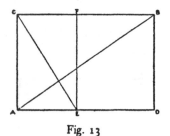

Fig. 13

Draw the rectangle CD, Fig. 13, and its diagonal AB. From F drop a perpendicular on the diagonal and continue it till it meets the line AD at E. The rectangle CE is the reciprocal of CD.

(2) By a right-angled triangle, one side of which is the diagonal of the rectangle, Fig. 14.

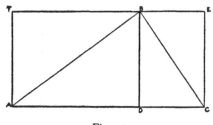

Fig. 14

Draw the rectangle FD, Fig. 14, and its diagonal AB. At right angles to AB draw the line BC. Complete the rectangle BC. ABC is a triangle right angled at B and the rectangle BC is a reciprocal to the rectangle FD.

(3) By "applying" a square on the end of the rectangle, Fig. 15.

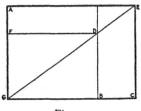

Fig. 15

Apply the square AB on the end of the rectangle AC, Fig. 15. Draw GE a diagonal to the whole. The side of the square AB cuts the diagonal of the rectangle AC at D. The end of the reciprocal shape is the line DB. Draw the line FD. FB is a reciprocal shape.

(4) By a semicircle, which described on the end of a rectangle, cuts the diagonal of the whole and the diagonal of the reciprocal at right angles, Fig. 16.

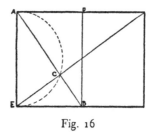

Fig. 16

Describe a semicircle on the end of a rectangle, Fig. 16. Draw a diagonal to the whole. The arc cuts it at C and a line from A through C to B is a diagonal of the reciprocal. Draw the line DB. ED is a reciprocal shape.

The point of intersection of the diagonal of a reciprocal with the diagonal of the rectangle is the pole or eye of a rectangular spiral, Fig. 17.

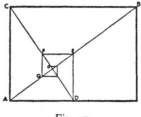

Fig. 17

AB, Fig. 17, is the diagonal of a rectangle, CD the diagonal of the reciprocal and BC, CA, AD, DE, EF, FG, etc., are the sides of a rectangular spiral whose pole is O. The spiral can never reach the point O.

The diagonal of a rectangle and a diagonal of its reciprocal cut each other to form lines in continued proportion, Fig. 18.

Fig. 18

BA, BC, BD, and BE, Fig. 18, are lines in continued proportion. That is, the line BA bears the same relation to the line BC as BC does to BD and BD to BE. BC, BD are two mean proportionals between the two extremes BA and BE. Also, AC, CD and DE, the sides of a rectangular spiral, are lines in continued proportion. Lines in continued proportion in a rectangle divide the area into proportional multiple and submultiple parts.

The area of the reciprocal to a root-two rectangle is one half the area of the whole; the area of the reciprocal to a root-three rectangle is one third the area of the whole; the area of the reciprocal to a root-four rectangle is one fourth the area of the whole and the area of the reciprocal to a root-five rectangle is one fifth the area of the whole, see Fig. 19.

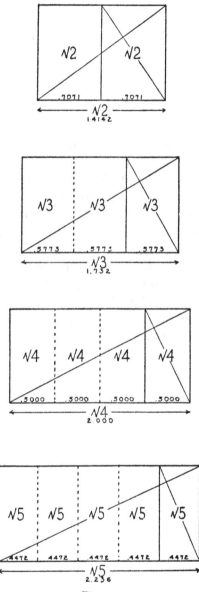

Fig. 19

LESSON 6

The Root-Two Rectangle (1.4142).

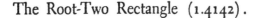

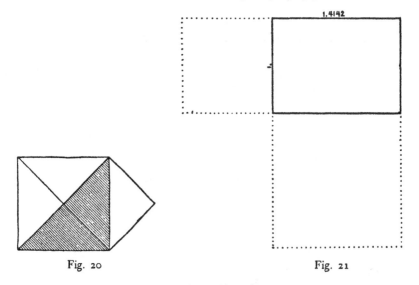

Fig. 20 Fig. 21

THE area of a square described on the diagonal of a square is double the area of the smaller square, Fig. 20. The rectangle obtained from a square, whose end is the end of the rectangle and whose diagonal is its side, is shown in Fig. 21. The square on the end of this rectangle is one-half the area of the square on its side.

This shape, Fig. 21, is called a root-two rectangle, because the relationship of its end to its side is that of one to the square root of two; 1:1.4142 plus. The end and side of a root-two rectangle are incommensurable, not measurable one by the other. They are, however, commensurable in square. (See Greek classification of incommensurables. Euclid, Book X.)

Fig. 22

Sides of the rectangular spirals in a root-two rectangle touch, Fig. 22.

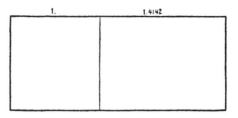

Fig. 23

A root-two rectangle plus a square on the end is expressed by the ratio 2.4142, Fig. 23.

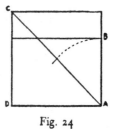

Fig. 24

A root-two rectangle is described within a square by half the diagonal of that square, Fig. 24. AB is equal to half the line AC. DB is a root-two rectangle.

Fig. 25*a* Fig. 25*b*

When root-two rectangles are described on the four sides of a square the area of the square is divided into five squares and four root-two rectangles, Fig. 25. (To construct see Fig. 24.)

Fig. 26

The reciprocal of a root-two rectangle, .7071, plus a square is expressed by the ratio 1.7071, Fig. 26.

Fig. 27

The ratio 2.4142, as an area, may be shown as a square plus the reciprocal of a root-two rectangle on either end, .7071 \times 2 + 1., Fig. 27.

In a root-two rectangle diagonals of the whole and diagonals of the reciprocals divide the area into a never ending series of smaller root-two rectangles, Fig. 28.

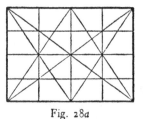

Fig. 28*a*

a. Continued subdivision of a root-two rectangle into similar figures, with a ratio of two.

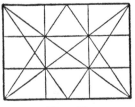

Fig. 28*b*

b. Continued subdivision of a root-two rectangle into similar figures with a ratio of three.

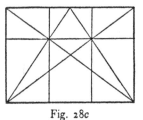

Fig. 28*c*

Fig. 28*c* illustrates the fact that the intersection of the diagonal of the whole rectangle with the diagonal of half the rectangle determines its division into thirds. This fact applies not only to the root-two rectangle but to all the rectangles and is therefore of great use to the designer.

LESSON 7

The Root-Two Rectangle and the Application of Areas.

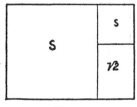

Fig. 29

WHEN the square on the end of a root-two rectangle is "applied" to the area of that rectangle, the excess area is composed of a square and a root-two rectangle, Fig. 29.

The application of areas to other areas may be made by geometrical construction or scale. For this purpose a metric scale is used.

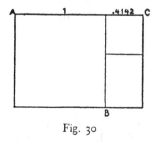

Fig. 30

The end of a rectangle is always regarded as 1. or unity. In the case under consideration, Fig. 30, AB is the square and the area BC is a square plus a root-two rectangle. The nature of the area BC is determined arithmetically by dividing the fraction .4142 into unity. $\frac{1}{.4142}$ equals 2.4142 and 2.4142 \times .4142 equals 1. The ratio 2.4142 is readily recognized as 1.4142 plus 1., *i.e.*, a square plus a root-two rectangle.

43

When a square is applied to each end of a root-two rectangle they overlap and the area of the rectangle is divided into three squares and three root-two rectangles, Fig. 31.

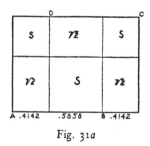

Fig. 31a

The area BC, Fig. 31a, is explained above and AD is equal to BC. The area DB is represented by the fraction .5858, and this is obtained by subtracting .4142 from 1. The fraction .5858, divided into 1. equals 1.7071. Of this ratio 1. represents a square and .7071 the reciprocal of 1.4142. In a root-two rectangle there are two reciprocals and the end of each is obtained by dividing 1.4142 by 2.

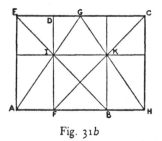

Fig. 31b

To construct Fig. 31a geometrically, draw the diagonals of the two applied squares EB, FC, Fig. 31b. Bisect EC at G. Draw the diagonals to the reciprocals AG, GH. These pairs of diagonals intersect at I and K showing that the resulting areas are all squares or root-two rectangles.

The diagonal of a root-two rectangle cuts the side of an applied square and divides the area of that square into two squares and two root-two rectangles, Fig. 32.

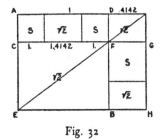

Fig. 32

The area CB of the square AB, Fig. 32, is a root-two rectangle, because its diagonal is the diagonal of a root-two rectangle. Its side, *i.e.*, AD or CF, is equal to unity, and its end CE equals .7071. The area CD is 1. on the side and the difference between .7071 and unity on the end. .7071 subtracted from 1. equals .2929. This fraction divided into 1. equals 3.4142, *i.e.*, 1.4142 plus 2, or two squares plus a root-two rectangle. The area BG must be equal to the area CD (see Fig. 35*b*). The line BH equals .4142. This fraction divided into unity, or HG, equals 2.4142, *i.e.*, 1.4142 plus 1, or a square plus a root-two rectangle. Every area in the root-two rectangle AH is now exhausted and the entire rectangle divided into a theme of squares and root-two rectangles. This method of area division may be applied to other rectangles.

When the square on the end of a root-two rectangle is applied to the side of that rectangle the area of the applied square is divided into two squares, Fig. 33.

Fig. 33

The application of a square on an end to a side of a rectangle, as shown in Lesson 3, is effected by a simple geometrical construction, Fig. 34.

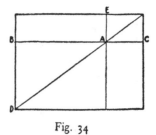

Fig. 34

The diagonal of a rectangle cuts the side of an applied square on the end as at the point A. The line BC through A determines the area DC. In a root-two rectangle BD is equal to .7071 and BC 1.4142 and .7071 multiplied by 2 equals 1.4142. This is a geometrical fact of great value to design and should be carefully considered. The geometrical proof that the area DE is equal to the area DC is furnished by similarity of figure, Fig. 35a and b.

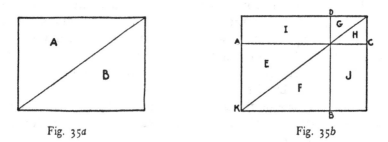

Fig. 35a Fig. 35b

A diagonal divides the rectangle into two equal and similar triangles, as A, B in a, Fig. 35. In b the area AB is divided into two equal and similar triangles E, F; G, H are also two equal and similar triangles and the area I must be equal to the area J, because (in a) area A equals area B. The triangles E, F are common to the square KD and the rectangle KC, and J of the area KC is equal to the area I of the square KD.

When a root-two rectangle is applied to the square of a 2.4142 shape the side of this rectangle produced through the major root-two rectangle determines two squares within that shape, Fig. 36.

Fig. 36

AB, Fig. 36, is a root-two rectangle applied to the square CB; the continuation of its side is the line AD; this line fixes the area BD, which is composed of two squares. (To describe a root-two rectangle in a square see Fig. 24, Lesson 6.)

The side of a square applied to the .7071 part (reciprocal of root 2) of a 1.7071 rectangle projected through the major square, defines a root-two rectangle in that square, Fig. 37.

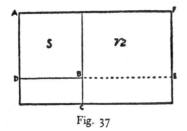

Fig. 37

AB, Fig. 37, is a square applied to the root-two rectangle AC; the side of this square DB, projected to E defines the root-two rectangle BF in the square CF.

LESSON 8

The Root-Three Rectangle (1.732).

IF the diagonal of a root-two rectangle is used as the side of a rectangle, the end of which is equal to the end of the root-two rectangle, this new rectangle is called a root-three rectangle. The end and side relationship of this rectangle is one to the square root of three, 1:1.732.

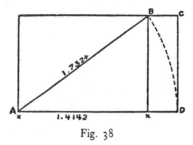

Fig. 38

AB, Fig. 38, is a root-two rectangle and its diagonal is equal to AD, the side of the root-three rectangle AC.

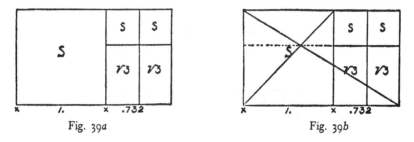

Fig. 39a Fig. 39b

If a square on the end is applied to a root-three rectangle the excess area is composed of two squares and two root-three rectangles, Fig. 39. Fig. 39b shows the construction.

48

If a square on the end is applied to the side of a root-three rectangle the area of the square changes from the form of a square to that of three squares, Fig. 40.

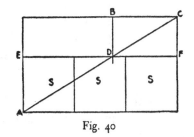

Fig. 40

AB, Fig. 40, is a square on the end of the root-three rectangle AC. A side of this square cuts a diagonal of the whole at the point D. The line EF determines the area AF, which is equal to the area of the square AB.

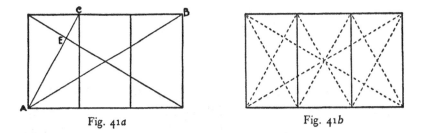

Fig. 41a Fig. 41b

There are three reciprocals in a root-three rectangle. AC, Fig. 41a, is a reciprocal of the root-three rectangle AB, and AC is one-third AB.

The diagonal of a reciprocal and the diagonal of the whole of the root-three rectangle cut each other at right angles at E, a pole or eye.

Fig. 41b shows a root-three rectangle and its three reciprocals with all the diagonals in position. It will be noticed that the diagonals of all the reciprocals cut the diagonals of the whole at right angles.

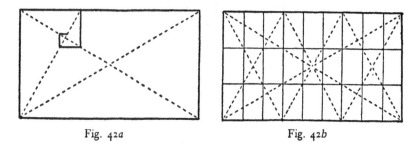

Fig. 42a Fig. 42b

Lines coinciding with the spiral wrappings of a root-three rectangle divide the area of that shape into an infinity of similar shapes to the whole. Fig. 42, *a* and *b*, shows this process.

Lines drawn through the eyes of a root-three rectangle divide the area of that shape into similar figures to the whole, to infinity, Fig. 43.

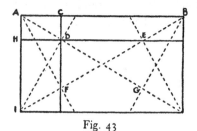

Fig. 43

The line AC, Fig. 43, is equal to one-fourth of the line AB, and AH is one-fourth of AI. The points D, E, F, G, are "eyes" or poles.

The area of a square on an end of a root-three rectangle is one-third the area of a square on a side.

LESSON 9

The Root-Four Rectangle (2.).

A DIAGONAL of a root-three rectangle is equal to the side of a root-four rectangle on the same unit base.

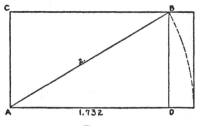

Fig. 44

CD, Fig. 44, is a root-three rectangle and AB, a diagonal, is equal to the side of a root-four rectangle if the line CA is the end of such a shape.

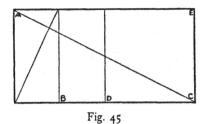

Fig. 45

The square root of four is two, consequently a root-four rectangle is composed of two squares. A reciprocal of a root-four rectangle is equal to one-fourth the area of that shape. AB, Fig. 45, is the reciprocal of the area AC, *i.e.*, it is the reciprocal of two squares and is itself composed of two squares. The excess area of a root-four rectangle, after a reciprocal has been defined, is composed of a square and a half or the figure BE. It will be noticed that a root-four rectangle may be

treated either dynamically or statically. It is found in Greek design used both ways.

When used dynamically it is subdivided either by root-five or the whirling square rectangle.

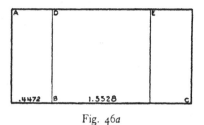

Fig. 46*a*

If the reciprocal of a root-five rectangle, *i.e.*, .4472, be applied to a root-four rectangle the excess area is represented by the difference between .4472 and 2, or 1.5528. AB, Fig. 46*a*, is a root-five rectangle reciprocal. DC is a 1.5528 rectangle. The fraction .5528 is the reciprocal of a 1.809 rectangle, consequently the area DC is equal to a square plus a 1.809 shape. The area EC is a root-five rectangle and BE is equal to .5528 multiplied by two or 1.1056, *i.e.*, 2 minus .8944, which is .4472 multiplied by 2.

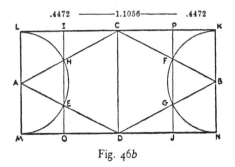

Fig. 46*b*

To construct Fig. 46*a* geometrically, bisect the sides of the root-four rectangle LN at A and B, as in Fig. 46*b*. Draw the root-four diagonals AC, AD, BC, BD. With A and B as centers or half the end of the root-four rectangle as radius, describe the semicircles LM, KN.

Where the semicircles cut the diagonals of the root-four rectangle, draw the perpendiculars IO, PJ. LO, PN are .4472 rectangles.

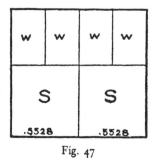

Fig. 47

If the 1.1056 area is divided in the middle and the two 1.809 rectangles defined, the entire area is divided into two squares and four whirling square rectangles, Fig. 47. The reciprocal of two squares is .5. Four whirling square rectangles, or .618 multiplied by 4, *i.e.*, 2.472, is .4045. This fraction plus .5 equals .9045, and this again is the reciprocal of 1.1056.

```
 ┌----- --1.618---┌-------┐
 ┆         ┆      ┆       ┆
 │ .382  │ .618  │ .618  │ .382 │
 ┆         ┆      ┆       ┆
 └-------- 1.618------ --┴------┘
```

Fig. 48

If a whirling square rectangle, *i.e.*, 1.618, be applied to a root-four rectangle the excess area is .382, Fig. 48. If a 1.618 rectangle be applied from the other end of the shape the two whirling square forms overlap and the area of the overlap is composed of two whirling square rectangles, *i.e.*, two .618 shapes or the rectangle 1.236. If the ratio 1.236 is subtracted from 2 the excess is .764 or .382 multiplied by 2. The fraction .764 is the reciprocal of 1.309.

Fig. 49

Consequently the area of a root-four rectangle may be considered as composed of two whirling square rectangles plus a 1.309 area, *i.e.*, a square plus two whirling square forms, Fig. 49.

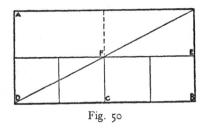

Fig. 50

If a square on an end be applied to a side of a root-four rectangle the area of the square changes its shape and becomes four squares, Fig. 50. AC is a square applied to the area of the root-four rectangle AB. A side of the applied square cuts the diagonal of the whole at the point F. The area DE is equal to the square AC, and is composed of four squares.

A root-four rectangle may be regarded as unity multiplied by 2, and any dynamic arrangement applied to one square is equally appropriate for two squares.

LESSON 10

The Root-Five Rectangle (2.236).

A DIAGONAL to a root-four rectangle becomes the side of a root-five rectangle on the same unit base.

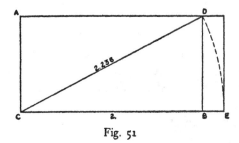

Fig. 51

AB, Fig. 51, is a root-four rectangle and CD is a diagonal. CE is made equal to CD. AE is a root-five rectangle. The area DE represents the difference between a root-four and a root-five rectangle, or .236. The square root of four is 2, and of five is 2.236. The ratio .236 represents a dynamic shape. Because it is less than unity it is the reciprocal of some ratio greater than unity. When .236 is divided into unity the ratio 4.236 is disclosed. This ratio or its corresponding area may be subdivided in many ways. It may be regarded as root-five, *i.e.*, 2.236, plus 2, or two 1.618 shapes, *i.e.*, 3.236, plus 1; as three squares plus two whirling square rectangles, *i.e.*, 3 plus 1.236; as 1.809 plus 2.427, etc. The .236 area occupies an important position when whirling square rectangles are comprehended within a square. When whirling square rectangles are described on the four sides of a square they all overlap to the extent of a .236 rectangle, Fig. 52. (For method see Fig. 87, Lesson III.)

Fig. 52

AB, CD, FE, GD, Fig. 52, are four whirling square rectangles described on the four sides of a square. They overlap to the extent of the areas GE and CH. These areas are .236 areas. If we subtract .236 from unity the remainder is .764, the reciprocal of 1.309, or a square plus two whirling square rectangles. The areas AC and BD, added, side to side, equal a 1.309 shape. So also do the areas AE and GI. If we divide .764 by 2 the result is .382 or the reciprocal of a 2.618 rectangle. AC, BD, AE and GI are these shapes.

When the square on the end of a root-five rectangle is applied to that area the excess area is composed of two whirling square rectangles, Fig. 53.

Fig. 53

AB is a root-five rectangle, AC is a square and CD, DB each a .618 or whirling square rectangle. The square root of five is 2.236. With 1 subtracted the remainder is 1.236: this divided by 2 equals .618.

A square on the end of a root-five rectangle applied to a side of that shape changes its form and becomes equal to five squares, Fig. 54.

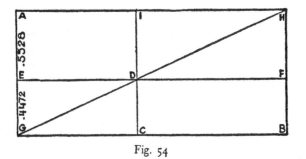

Fig. 54

AB is a root-five rectangle, AC is a square applied on the end. A side of this square is IC and it cuts a diagonal, as GH, at D. The line EF is drawn through D parallel to GB. The area EB is equal to the area AC, and EB is composed of five squares.

If we take the area of the root-five rectangle, as shown in Fig. 54, with the five squares defined by EB and divide the entire area into its reciprocals, *i.e.*, into five equal parts as shown in Fig. 55, it will be noticed that each reciprocal stands with a square applied on its end.

Fig. 55

For each reciprocal of the root-five area, as AB, we have the square CB and the excess area CD. Because a reciprocal of a rectangle is a similar shape to the whole AB is a root-five rectangle and the line EB

Fig. 55 *

is one-fifth of the line EF or .4472 (2.236 divided by 5 equals .4472).
The line CE equals .4472.

The line AE equals 1; AC therefore is equal to 1 minus CE or 1
minus .4472, *i.e.*, AC equals .5528. EF equals 2.236 and .5528 divided
into this ratio equals 4.045. If we divide the ratio 4.045 by five we
obtain the reciprocal ratio .809. This fraction is the reciprocal of
1.236, or .618 multiplied by 2, *i.e.*, the area CD is equal to two whirl-
ing square rectangles and the area AG is composed of ten such shapes.

* Diagrams are repeated when necessary to concur with the text.

LESSON 11

The Spiral and Other Curves of Dynamic Symmetry.

I⟶ will be necessary for students of dynamic symmetry to construct geometrically the logarithmic or constant angle spiral. As was mentioned in the chapter on Phyllotaxis, this curve appears to be the growth curve in plants. Inasmuch as the middle one of any three radii vectors, equiangular distance apart, is a mean proportional between the other two, we are able to draw this mathematical curve with ease and accuracy.

The first geometrical discovery made by the Greeks, in fact the first general law discovered by man, of which there is record, was that the angle in a semicircle is a right angle. Fig. 56 makes this clear.

Fig. 56

ABC is a semicircle and AC is a diameter. BAC is a right angle. So also are DAC, EAC, FAC, GAC and so on.

Another great discovery, made later, was that a line dropped from the juncture of the two legs of a right-angled triangle to meet the hypotenuse, was a mean proportional between the two segments of the hypotenuse as cut by this dropped line.

Fig. 57

BAC, Fig. 57, is a right-angled triangle and BD is a mean proportional between AD and DC. By the principle inherent in Fig. 56, the line AC of Fig. 57 is a diameter to a circle and the points A, B and C lie on the circumference of half of this circle.

Fig. 58a Fig. 58b

Suppose A, B, C and D, Fig. 58a and b, are points on the curve of a logarithmic or constant angle spiral and OA, OB, OC, OD are radii vectors equiangular distance apart. By definition OC is a mean proportional between OB and OD. Or OB is a mean between OA and OC. But suppose we wish to find points on the curve other than A, B, C and D; say between C and D. In that case we must find a mean proportional between OC and OD. This is done by bisecting the angle DOC. A line is drawn equal in length to OD plus OC, Fig. 59.

Fig. 59

This line is bisected at E, Fig. 59. Then CE is equal to ED. With radius equal to CE or ED describe the semicircle CFD and, perpendicular to CD, draw the line OF. This line OF is a mean proportional between OC, OD, and F, Fig. 58a, is a point on the curve.

To find other points on the curve bisect angles like FOD or FOC, then add together the lines FOD or FOC, bisect them as described in Fig. 59, construct on these added lines as diameters a semicircle and draw the required mean proportional line as described. By this process any number of points may be found on the spiral curve.

In geometry a mean proportional line is equivalent to a square root. By definition a mean proportional line is the side of a square equal in area to the rectangle contained by the two extreme lines. If we construct a square on the line OC of 58a, this square is equal in area to the rectangle made by OB as end and OD as side. That is, the line OC is the square root of OD, OB.

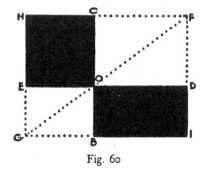

Fig. 60

The simple geometrical proof that the square EC is equal in area to the rectangle OI is obtained by completing the rectangle of which GF is a diagonal, Fig. 60. The triangle HGF is similar and equal to GIF. ODF is similar and equal to OCF, GEO is similar and equal to GBO. Consequently the area EC must be equal to the area BD.

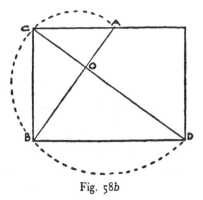

Fig. 58*b*

In Fig. 58*b* we have a rectangle with a diagonal to the rectangle and a diagonal to the reciprocal; they cut each other at right angles at O. Because of this OA, OC, OB, OD, are points on the curve of a logarithmic or equiangular spiral. OC is a mean proportional between OA and OB, and OB bears the same relationship to OC and OD.

We find other points on this curve by the process described above.

By definition the lines OA, OC, OB and OD, Fig. 58*b*, are in continued proportion. That is, OA is to OC as OC is to OB and OC is to OB as OB is to OD, and OC, OB are two mean proportionals between OA and OD. In other words, these lines furnish us with a graph of the simple rule of three. If we substitute numbers for these lines their relationship will be more obvious.

Suppose we give OA, Fig. 58*b*, the value of two and OC four; then OB must be eight and OD sixteen. Four and eight are means and two and sixteen are extremes. In four terms in continued proportion the product of the means is equal to the product of the extremes. Four multiplied by eight equals thirty-two; so does two multiplied by sixteen. OA, OC and OB are three terms in continued proportion. According to the numerical value given to these lines OC multiplied by itself or squared is equal to OB multiplied by OA. Four times four equals sixteen and twice eight equals sixteen.

But we may draw a logarithmic spiral within a rectangle:

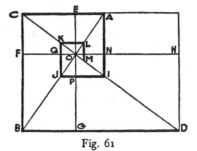

Fig. 61

In Fig. 61, O is the pole of a logarithmic spiral determined by the line BA crossing CD at right angles. Through this pole we may draw the lines EG and FH. H, G, F, E, N, P, Q, etc., are points on a logarithmic spiral curve contained in the rectangle CD and other points on this curve may be found as described above.

It is suggested that the student draw and redraw these simple diagrams until he thoroughly understands the principles involved, as he will find they will prove of great help to him in future work.

During the entire period of Greek classic design the construction of the spiral curve seems to have been a matter of constant experiment. A comparative study of the Ionic volute makes this fact clear. Fig. 62 shows the construction of volutes of different kinds by straight lines.

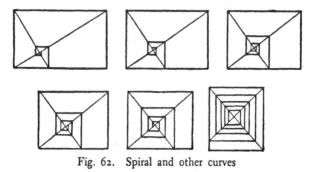

Fig. 62. Spiral and other curves

Having a satisfactory volute arrangement in straight lines the construction of the curve is a very simple matter; it may be made free hand, by circle arcs of varying radii or by geometric construction as previously described. Of course the actual Ionic volute was in a rectangle which was some logical division of the rectangle that contained the entire column and this again was a logical part of the shape which contained the entire building.

LESSON 12

General Constructions for Similarity of Figure.

THE average modern artist knows that rectangular shapes are enlarged or reduced by a diagonal. If the painter or designer desires to make a shape similar to the shape of his canvas, or to any other rectangular area he may be using, he draws a diagonal. Any rectangular figure with a diagonal common to the diagonal of the whole is similar. Fig. 63 shows this.

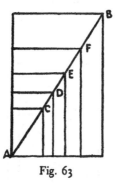

Fig. 63

AB is a diagonal to any rectangular area. The areas AC, AD, AE, AF are similar figures to the whole, because their diagonals are common to the shape AB. The modern artist also knows that similar figures to the whole may be constructed as in Fig. 64.

This property of the diagonal is used extensively in the arts, particularly the reproductive arts, to enlarge or reduce drawings. This knowledge proves its value every day in the arts, but it is insufficient. There are many cases wherein similarity is not only desirable but necessary, and for such the method described does not apply. Figs. 63 and 64 show similar shapes either centered in the

parent form or moving up or down on either one of the two diagonals.

Fig. 64a Fig. 64b

But suppose a similar figure is desired which can be moved up or down on a medial line and, therefore, must be unsymmetrical with the top and bottom line of the enclosing space. Fig. 65, *a*, *b* and *c*, shows how this may be accomplished.

Fig. 65a Fig. 65b Fig. 65c

Suppose it is desired to construct a similar figure to the whole upon the line EF in the rectangle AB of Fig. 65a. CD is a medial line. From the corners GB of Fig. 65b draw the lines GI and BI, passing through the points E and F. Also draw the lines AI, HI and complete the rectangle. Fig. 65c furnishes the proof that the rectangle EF is a similar shape to the whole constructed on a medial line. The lines GI, BI, AI and HI of *b* are diagonals to areas which exhaust the area

AB. These diagonals are also common to diagonals of areas which exhaust the area EF of *c*.

Suppose, for example, it is desired to construct a similar figure to the whole from any points in a given rectangle. Fig 66 shows the process.

Fig. 66*a* Fig. 66*b*

We shall assume that the line upon which the similar figure is to be constructed is AB of Fig. 66*a*. Draw the lines GE, BE, as in *b*, passing through the points C and D; also the lines AE, FE. Complete the rectangle. The area CH is a similar shape to the figure AB for the same reasons given for Fig. 65.

The constructions for the definition of similar figures, of course, apply to any rectangle. It is advisable, however, to use only the rectangles of dynamic symmetry, because of their measurable properties. Unless rectangles are used which possess this dynamic property of modulation and measurableness it will be impossible to give design the vital qualities of life and growth. Design created within rectangles which do not possess this function of commensurable area are always flat and dead.

Using dynamic rectangles we may construct within them either a similar figure to the whole in any position, where sides and ends are parallel to those of the parent figure, or a figure which is similar to any dynamic subdivision of that area. Assume, for example, that it is required to draw a square in some place, within the major square of a whirling square rectangle. In that case the asymmetric diagonals will appear as in Fig. 67.

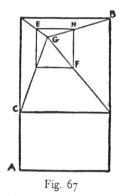

Fig. 67

AB is a whirling square rectangle and CB is its major square. EF is a square in some position within the area of the major square. Again, it is better to select a point, as G, which is a dynamic point, or a line, as EH, which is a dynamic line. The arrangement of Fig. 67 applies to any dynamic area other than the square and the points for these areas may be either on the side or end of the parent rectangle. Fig. 68 will make this clear.

Fig. 68

AB is a dynamic rectangle and C is a dynamic point of subdivision on one end. EF is a dynamic rectangle similar to the area CG.

Any dynamic subdivision of a dynamic rectangle is like a seed endowed with the eternal principle of growth. It possesses the property of expanding or dividing until it includes the entire dynamic system. Like an osier twig planted in congenial soil which soon develops into a beautiful tree, dynamic shapes have in them the life impulse which causes design to grow.

PART II

COMPOUND RECTANGLES

LESSON I

The Complement.

In the first part of these lessons the reciprocal of a shape was explained in some detail. There is, however, another important element which has not been mentioned. This is the complement of a shape. We may compare a form complement to a color complement.

If we select any color, the complement of it is that quantity of color necessary to balance or neutralize it. For example: if a blue be selected its complement will be an orange; if a green, then a pinkish crimson; if a yellow, then a violet, etc. We may reverse the process and select orange, crimson or violet. Then the complements will be blue, green and yellow. This complement balance is well understood by color authorities. It is not so well known, however, that if the selected color is debased with light or dark, the complement must also be debased in reverse order.

For example: if we debase a blue with light, its complement, orange, must also be debased with dark in due proportion. The exact percentage of debasement is beautifully illustrated by a simple experiment in photography. If we wish to determine the exact complement, say, of a blue debased with light, this color is photographed on a color plate, preferably a Lumière plate. After the exposure this plate is then developed as a *negative*. Ordinarily it is developed as a positive and used as a transparency.

This negative color plate will show the exact complement of the blue color which was debased with light, *i.e.*, it will appear as an orange, properly debased with dark to make the precise complementary balance for the blue. In other words, a negative is a complement. Students are all familar with an ordinary black and white negative. Artists of course make necessary complementary mixtures in pigment by eye. The student, however, must train his eye, and for this purpose I know of nothing better than a number of color plate negatives wherein the original color has been debased by light or

dark in various ways. For the artist's palette "white" is substituted for "light."

The complement of a shape is that area which represents the difference between the selected figure and unity.

For the purpose of finding a complement it is first necessary to reduce the ratio of the selected area to its reciprocal form, that is, divide it into unity.

For example: the ratio of a root-five area is 2.236 and the reciprocal .4472. .4472 subtracted from one leaves .5528. This is approximate but accurate enough for working purposes. .5528 is the reciprocal of 1.809.

The complement of a root-five rectangle, whether expressed by 2.236 or .4472, is .5528 or 1.809. A diagram will help to emphasize the relation.

Fig. 69

AB of Fig. 69 is a root-five rectangle. CD is a 1.809 rectangle and CB is a square. AD equals 1, AJ .4472 and CA .5528. CD is composed of the square CE and the two whirling square rectangles EF and FG. AB is composed of the square EB and the two whirling square rectangles AH and HE. GB is also a root-five rectangle composed of EB, EF and FG. Also CI is a 1.809 rectangle composed of CE, EH and HA.

We learn from this arrangement of an area and its complement that a certain part of each area is common to both, as, in this case, GD and AI, while the two remaining areas are similar in shape but are different in size.

This complement arrangement applies to any rectangular area. In Fig. 70, the area CD is the complement of AB, and EF is similar and equal to GE, while CE and EB are similar figures of unequal area.

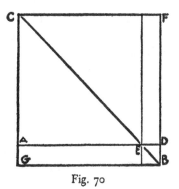

Fig. 70

The point for us to bear in mind is that there is an intimate relation between areas and their complements, and whatever arrangement is made in one necessitates a complementary or reverse action in the other.

A division in a 1.809 rectangle, for example, automatically produces a reverse arrangement in a root-five rectangle.

In painting, if we wish to secure force and emphasis, whatever we do with a color we also do in reverse order to its complement. It will be impossible for the artist to be master of his means of expression unless he understands the nature of this automatic action. His feeling and sense of fitness will help him to overcome many difficulties, but he will not come into his full heritage until he comprehends what he is doing.

The photographic color plate shows us that, if we add or subtract a color element to or from another color, we must subtract or add the complement of such addition or subtraction to or from the complement of the original color.

We apply the same idea to areas.

It will be noticed that any rectangle, with its complement, forms a square, and that subdivisions of either the rectangle or its complement may be considered as subdivisions of this square.

Those familiar with the primary steps of geometry will recognize the similarity between a square divided in this manner and most of the problems of the second book of Euclid.

Authorities agree that most of the substance of this book had an early origin in Egypt. The ancient idea as it has survived to us was the dividing of a line and the fixing of the relationship between the areas of the squares and rectangles on this line and its segments.

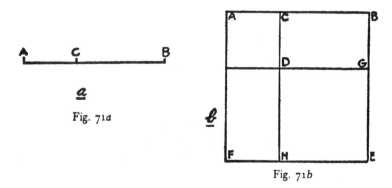

Fig. 71a

Fig. 71b

AB, Fig. 71a, is any line cut at any point, say C. Fig. 71b is a square constructed on AB. AD, DE are squares on the segments AC, CB. DB, DF are rectangles formed by the segments AC, CB. The square on AB is equal to the squares on AC and CB plus twice the rectangle on AC, CB, etc., etc.

Let us suppose, for example, that a painter is using a rectangular canvas, as CE. The complementary shape to this canvas is an imaginary area.

It would not occur to many that the canvas CE could be divided dynamically in terms of the imaginary area AH.

It will prove profitable practice for the student to divide the areas of his designs in terms of their complements.

As simple as the arrangement of areas is in b, Fig. 71, it will nevertheless require some ingenuity to figure out arithmetically the exact relationship of the areas when they are made by dynamic cutting.

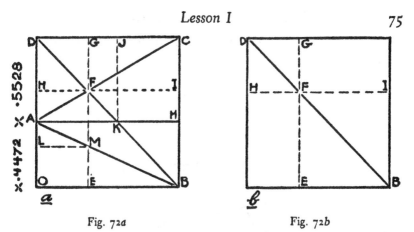

Fig. 72*a* Fig. 72*b*

Let AB, Fig. 72*a*, be a root-five and AC a 1.809 rectangle. DB is a diagonal to the major square. AC is a diagonal to the 1.809 and AB a diagonal to the root-five rectangle. F is an intersection of AC and DB. Through F draw GE and HI. What are the areas AE, LE, HE, GI, GN and JI?

It is clear that GI and HE of *b* are equal and similar figures, and that DF and FB are squares of unequal area.

In *a*, DF is a square, while AF is a similar figure to AC because they have the same diagonal. AG therefore must be equal to a square plus a .5528 area, that is, AG must be a 1.5528 rectangle. Or we might say a square plus a square and an .809 rectangle. We now need the actual numerical length of DG. DA we know is .5528, while DC is 1. To obtain the length DG we must multiply DA, or .5528, by the reciprocal of 1.5528. This is .644. We thus obtain .356 for the length DG, while GC is 1 minus .356, that is .644.

We may obtain this result in another way. The area DI of *a* is equal to the square DF plus the 1.809 area GI, *i.e.*, DI is a 2.809 rectangle. The reciprocal for a 2.809 area is .356 or the length DH or DG.

We know that the length AO is .4472, because AB is a root-five rectangle. The area AE, .356 by .4472, is found by dividing the lesser into the greater number. The result of this division is 1.2562, or .809 plus .4472, a compound of part of the complement and the root-five area. The area AM is this root-five area while LE is the .809 figure. JN and AE are similar shapes, each composed of two whirling square rectangles.

Suppose we fix a reciprocal in a complement of a root-five rectangle.

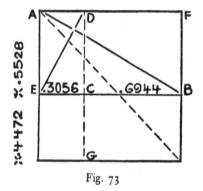

Fig. 73

AC of Fig. 73 is the reciprocal of AB. To find the length AD we must multiply AE by .5528, that is, we must square this number. The result is .3056. We might also divide .5528 by 1.809. DF equals 1 minus .3056 or .6944. .4472 divided into .6944 equals 1.5528 for the area GB. EG is the difference between 2.236 and 1.5528, *i.e.*, .6832, or .4472 plus .236.

Of course it is not necessary for an artist in his practice to resort to this arithmetical calculation any more than it is necessary for him to figure out precisely his perspective, but, as is also necessary with perspective, before he can use symmetry freely he must understand it, to the end that his intention may be rational. In fact *intention* is the dominant factor in artistic as in other forms of expression.

If the artist has not a clear conception of what he intends to do, his acts will lack force and distinction no matter how strong his intuition may be.

In practice the artist's greatest dependence will rest upon his use of diagonal lines.

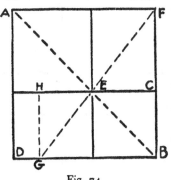

Fig. 74

AB of Fig. 74 is a square; DC is a root-five and AC a 1.809 rectangle. AE is a square, consequently EF must be an .809 shape. EF is a diagonal to this area. Produced from E to G the area EG becomes an .809 shape and EB is a square. GC is a 1.809 rectangle applied to the root-five area DC. DH is the difference between 2.236 and .809, or .427. If the .427 area DH is applied to the other end of the root-five shape, the area in the middle will be a 1.382 figure.

This simple operation divides the root-five area into terms of its complement in a very suggestive manner. This process applies to any rectangle and its complement where the latter is greater than one-half the major square.

To transfer a complement, the width of which is less than one-half the major square:

Construct a square, the sides of which are equal to the width of the complement, and produce one side to the opposite side of the major square, Fig. 75.

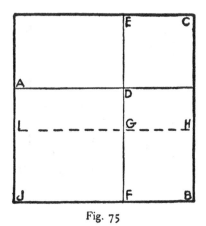

Fig. 75

AB, Fig. 75, is any rectangle; AC is its complement; DC is a square in the complement. ED, a side of this square, is produced to F, and GF is made equal to DE. Draw IH through G, parallel to JB. The area IB is the transferred complement AC. Suppose AB is a whirling square rectangle in the square JC. The complement AC is a .382 rectangle, *i.e.,* a 2.618 area.

AE is a whirling square rectangle, as is also DB, and DC and DJ are squares. If IB and AC are 2.618 rectangles the area AH is .236, *i.e.,* a 4.236 shape.

Artists will frequently find it necessary in their practice to construct different rectangles in single and multiple form within the areas of their designs.

The process for doing this is very simple.

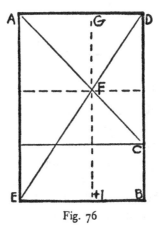

Fig. 76

Let AB, Fig. 76, be a rectangle, say, 1.4472—a square plus a root-five shape. Suppose we wish to apply to a side of this selected shape a 2.4472 area. Apply a square on an end, and let AC be its diagonal. ED is a diagonal to the major area, and the two diagonals cut each other at F. Through F draw GH, parallel to AE or DB. AH is a 2.4472 rectangle. So also is GC.

LESSON II

Rhythmic Themes of the Whirling Square Rectangle.

In Lesson 2, Part I, we learned how to construct the two most important shapes of dynamic symmetry, the root-five rectangle and the rectangle of the whirling squares.

It is now necessary to study the methods of making logical subdivisions of these rectangles so as to form themes in area for design purposes. The area themes found in Greek art teach us that the great majority of classic designs were made to conform to certain compound shapes. These shapes may all be reduced to arrangement themes composed of root-five or the whirling square rectangle or to some clearly defined subdivision or multiple of them.

Fig. 77 Fig. 78
Root-five rectangles within the rectangle of the whirling squares.

Draw a whirling square rectangle, the diagonals to the whole and the diagonals to the two reciprocals. These diagonals cross at the points A, B, C and D, Fig. 77. These points are called the poles or eyes of a rectangle. Through the eyes AB, Fig. 78, draw the line CD, parallel to the sides of the rectangle. The area CE is a root-five rectangle. AF is a square and GA and BE are whirling square rectangles.

Arithmetical analysis:

If the line HG, Fig. 78, represents unity or 1. and GE 1.618 then CG equals .7236. The student is advised to construct this shape with a metric scale and study closely the subdivided area. The reciprocal of the square root of five is .4472. The line GE being the side of a whirling square rectangle, is numerically expressed as 1.618. This number multiplied by the reciprocal of the square root of five, that is, .4472, gives us the numerical value of the line CG, or .7236. This fraction .7236 divided into 1.618 equals 2.236, or the square root of five. The area CE, therefore, is a root-five rectangle.

If, through the eyes AB of the whirling square rectangle CE, Fig. 79, the line FD is drawn parallel to the ends of the rectangle, it determines the area CD. This area is that of a root-five rectangle and is composed of the square GA and the two whirling square rectangles CA and HB. The student should remember that we are dealing with similarity of shapes of areas and not sizes.

Fig. 79 Fig. 80

Arithmetical analysis:

If the line CH of Fig. 79, is unity or 1. and the line HE is 1.618, and the area CD is a root-five rectangle, then the line HD is represented by .4472. HD or .4472 divided into CH or 1. equals 2.236 or the square root of five.

Obviously, from the above construction, we may draw lines through the eyes A, B, C and D, as in Fig. 80, and divide the area of the whirling square rectangle EF into four overlapping root-five rectangles, MF, EP, EG and KF; AJ, ID, OA and BP are squares, and EA, HA, HC, OI, BL, DF, KP and BF are whirling square rectangles.

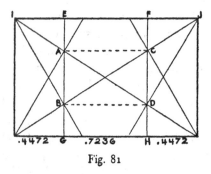

Fig. 81

Other subdivisions of the whirling square rectangle:

If the lines EG and FH are drawn through the eyes A, B, C and D of Fig. 81, and the areas IG and HJ are root-five rectangles, then the area EH is a .7236 area. The total length IJ equals 1.618. IE equals .4472 and FJ .4472. These two fractions added equal .8944; this subtracted from 1.618 equals .7236. The fraction .7236 divided into unity or 1. equals 1.382.

The area EH, therefore, may be represented by the ratio 1.382 or its reciprocal .7236. AH is a square or 1. and EC is a .382 rectangle. This fraction divided into unity or 1. proves to be the reciprocal of 2.618.

Therefore, the area EC may be expressed by the ratio 2.618 or its reciprocal .382. The ratio 2.618 equals 1.618 plus 1. Therefore, the area EC equals a whirling square rectangle plus a square. The area is similar and equal to the area BH.

Consequently, the line BG is of equal length with the line EA or is .382. BG added to EA is equivalent to multiplying .382 by 2. It produces .764.

The whole line EG equals 1.382. We are now speaking of the rectangle EH and considering EF or GH as unity. If from EG we subtract BG and EA, or .764 from 1.382, the remainder, .618, represents the line AB. The rectangle AD, therefore, is a whirling square rectangle; AB equals .618 and BD equals 1.

Fig. 82

If the line EF is drawn through the eyes A, B of the whirling square rectangle CD, Fig. 82, it defines the root-five rectangle CF. The line CE equals .4472, and the line EH equals 1.618 minus .4472 or 1.1708. This ratio divided into unity or 1. produces its reciprocal .854. The area ED, represented by the ratio 1.1708 or its reciprocal .854, is composed of the root-five rectangle GH plus the 1.382 area EG. If a 1.1708 were used for the purposes of design, one way of subdividing that area would be as described.

Summing up this lesson the following ratios appear other than those of the root-five and the whirling square rectangles:

Ratios	*Reciprocals*
1.3827236
2.618382
1.1188944
1.309764
1.1708854

The ratios 1.118 and 1.309 appear indirectly through their reciprocals, .8944 and .764. The ratio 1.118 may be found by dividing the square root of five, 2.236, by 2. The 1.309 shape will be recognized as a square plus two whirling square rectangles. .618 divided by 2 equals .309. The fraction .309 is the reciprocal of 3.236 or 1.618 multiplied by 2.

LESSON III

The Square Plus a Root-Five Rectangle (1.4472) and a Whirling Square Rectangle Applied to a Square.

HAVING considered the whirling square and root rectangles in a general way and indicated the manner by which the simple operations of arithmetic may be used to prove geometric construction and reduce areas to understandable forms, we are in a position to take up the great class of compound shapes.

One of the most important of these is represented by the ratio 1.4472. This is the key ratio for the Parthenon plan and appears as an area motif many times in Greek design. We find a natural source for this rectangle in the regular pentagon. The ratio of the radii of the inscribed and escribed circles of a regular pentagon is 1: .809. The fraction .809 is the reciprocal of 1.236 (.618 multiplied by 2). It is also equal to 1.618 divided by 2. The relation of this ratio to the whirling square scheme is, therefore, apparent. The reciprocal of the square root of five is .4472, consequently the ratio 1.4472 represents a square plus a root-five rectangle.

If a circle is drawn within a square and within that circle a regular pentagon is drawn, as Fig. 83, the area fixed by the intersection of two diagonals of the pentagon is a 1.4472 shape.

AB (a) is a square plus a root-five rectangle for the following reasons:

In Fig. 83b the line AB is the radius of an inscribed circle to a regular pentagon; AC is the radius of the escribed circle. If AC equals unity or 1, then AB is .809; that is, CI equals .809. IJ is the difference between .809 and 1. or .191. The line AE has an angular relationship to the line AC of 18 degrees. The sine of 18 degrees is .309. The line KJ equals twice unity or 2. EC equals .309; CI, .809 and IJ, .191; added these lengths equal 1.309. This number subtracted from 2

Fig. 83*a* Fig. 83*b*

leaves .691. This fraction is the reciprocal of 1.4472. The area HE, therefore, is composed of a square plus a root-five rectangle, and the line HE is a diagonal. The angle at H is similar to the angle at E, therefore the area LK is also composed of a square plus a root-five rectangle.

How to draw a square plus a root-five rectangle:

Fig. 84*a* Fig. 84*b*

Draw a square as AB, Fig. 84*a*, and bisect its area by the line FD. Draw AD (this being the diagonal to two squares) and with the point D as center describe the semicircle BEC. The circle arc cuts the line AD at E. Through E draw the line GH. The area HB is a root-five rectangle.

In Fig. 84*b*, BC is equal to HC of *a*. The area AD is a square plus a root-five rectangle. The ratio 1.4472 divided by 2 equals the reciprocal ratio .7236. This is the reciprocal of 1.382.

There is a definite connection between the ratio 1.4472 and 1.382 which is not apparent by geometrical construction. Indeed, every ratio of the dynamic planning scheme is connected with some other ratio by division and by reciprocal. The ratio 1.382 divided by 2 equals .691, the reciprocal of 1.4472. Every 1.382 rectangle, therefore, may be interpreted as composed of two squares plus two root-five rectangles and every 1.4472 shape may be considered as two 1.382 figures.

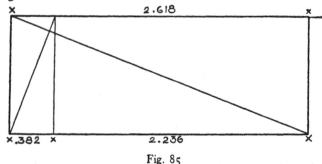

Fig. 85

The fraction .382 is the reciprocal of 2.618; the fraction .4472 is the reciprocal of 2.236 or the square root of five. 2.236 subtracted from 2.618 equals .382. The 2.618 shape minus its reciprocal .382 equals 2.236. Fig. 85 shows the geometric picture of this relationship of area.

Fig. 86

The fraction .382 is the difference between unity or 1. and .618. When a whirling square rectangle is applied to a square the excess area is equal to a square plus a whirling square rectangle; 1.618 plus 1. or in reciprocal form .382, Fig. 86.

A whirling square rectangle is applied to a square by the following method, Fig. 87.

Fig. 87

Draw a square, as AB, Fig. 87, and bisect the area by the line CD. Draw AD and make ED equal to GD. Make AF equal to AE and draw the line FH. The area AH is a whirling square rectangle. AG = 1. GH = .618 and HB = .382.

When diagonals to the whole and diagonals to the reciprocals are drawn to a whirling square rectangle comprehended within a square, a small square is defined whose center coincides with the center of the major square, Fig. 88.

Fig. 88a Fig. 88b

If the sides of this square are produced to the sides of the major square as shown by the lines AB, DC, GH and EF, Fig. 88b, the area of the major square is subdivided into a nest of whirling square rectangles, as JH, EK, AI, JD, EA, DF, CH, GB, EL, MF, etc. JI equals 1. JB .382 and CI .382; these multiplied by 2 equal .764. The line BC is the difference between .764 and 1. or .236. BA equals 1. Unity divided by .236 equals 4.236; BD is a 4.236 rectangle; that is, it is a shape composed of a root-five rectangle, 2.236, plus two squares; or two whirling square rectangles, 1.618, multiplied by 2 plus one square, 3.236 plus 1. GF is a similar area.

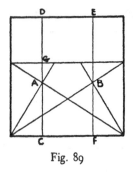

Fig. 89

If lines are drawn through the eyes of a whirling square rectangle comprehended within a square and produced to the opposite sides of that square they define the area of a root-five rectangle. A, B, Fig. 89, are the eyes mentioned, and DC, EF are the two lines. CE is a root-five rectangle, AF is a square and AE two whirling square rectangles.

LESSON IV

Compound Rectangles Within a Square.

A ROOT-FIVE rectangle is drawn within the area of a square as shown in Fig. 84 of the last lesson. When this root-five area is placed within a square it becomes necessary to define the nature of the area of the square in excess of the root-five shape.

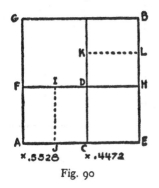

Fig. 90

AB, Fig. 90, is a square and CB is a root-five rectangle. This shape is composed of the square DE and the two whirling square rectangles DB. If the side of the square DE, as HD, is produced to F, the area FE is also a root-five rectangle. When the root-five area CB or FE is applied to a square the excess area is GC or GH. Because the area DE is a square and its sides HE, EC are common to the sides of the major square EB, EA, the diagonal DE is common to the diagonal of the major square GE; consequently GD is a square. And the area GC or GH is composed of the square GD plus the shape FC or DB. But the areas DB or FC are each composed of two whirling square rectangles. GC or GH, therefore, is composed of a square plus two whirling square rectangles. But a root-five rectangle is composed of a square plus two whirling square rectangles.

The difference between the shapes GC and CB lies in the fact that in CB, the side of the square DE as DH, is also the side of one of the whirling square rectangles, as KH. The side of the square GD, as FD, is also the ends of the whirling square rectangles FJ, JD. And the square GD is larger than the square DE. The difference between these two shapes is shown in Fig. 91, *a* and *b*.

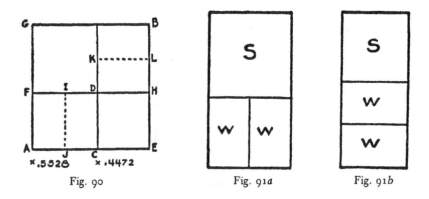

Fig. 90 Fig. 91*a* Fig. 91*b*

Fig. 91*a* is the GC shape and Fig. 91*b* is the CB shape of Fig. 90. The difference between the two shapes consists in the manner in which two whirling square rectangles are joined to a square.

If the side of the major square, as AE, Fig. 90, represents unity, or 1., then the line CE is equal to .4472 and AC is equal to .5528. These two numbers, added, equal 1, or the line AE. GC, therefore, if GA equals 1, is a .5528 rectangle and CB a .4472 rectangle. These numbers are less than unity, however, consequently are reciprocals of ratios greater than unity. .5528 divided into 1 equals 1.809 and .4472 divided into 1 equals 2.236. GC may be identified by either 1.809 or .5528, and CB by 2.236 or .4472. A 1.809 rectangle frequently occurs in Greek design. .809 is equal to 1.618 divided by two. One of its natural sources is shown in Fig. 92.

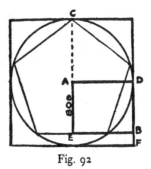

Fig. 92

In this diagram a regular pentagon is inscribed in a circle (see last lesson). The point A is the center of the circle. The line AD equals 1., the line AE equals .809. The area AB, therefore, is an .809 rectangle. CD is a square and CB is a 1.809 rectangle.

.809 divided into unity equals 1.236. It is therefore the reciprocal of 1.236 or .618 multiplied by two. A mathematician would describe a .618 rectangle as root-five minus one divided by two. Root $\dfrac{5-1}{2}$ *i.e.*, 2.236 — 1. equalling 1.236 and this divided by two producing .618. Fig. 93 shows the .809 and 1.236 shapes.

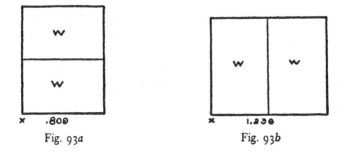

Fig. 93*a* Fig. 93*b*

The mathematician would describe a 1.618 rectangle as root-five plus one divided by two, root $\dfrac{5+1}{2}$, *i.e.*, 2.236 plus 1 being 3.236 and this divided by two producing 1.618.

The reciprocal ratio .618 subtracted from .809 equals .191. The area which is represented by .191 is that of EF in Fig. 92. The character of this area will be apparent if .191 is multiplied by two, .191 multiplied by 2 equals .382. As has been explained in the last lesson .382 is the reciprocal of 2.618, *i.e.*, it is a square plus a whirling square rectangle. Dividing .382 by 2 is equivalent to multiplying 2.618 by 2. An arithmetical operation applied to a reciprocal is always the reverse of the operation applied to a direct ratio. 2.618 multiplied by 2 equals 5.236, this equalling 1.618 multiplied by 2, or 3.236, plus 2. Fig. 94 shows the arrangement.

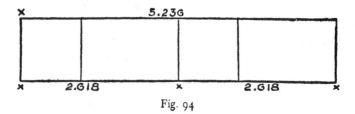

Fig. 94

The ratio 5.236 divided into unity or 1. equals .191. Both in nature and in Greek art the fraction .191 is frequently encountered as part of a compound shape. .809 plus .191 equals 1.

The ratio 1.236 plus .191 equals 1.427 and this result plus .191 equals 1.618. 2.236 plus .191 equals 2.427, and this divided by 3 equals .809.

The reciprocal ratio .427 plus .191 equals .618. The ratio 1.191 is an important ratio in Greek design. This area may be regarded as composed of an .809 plus a .382 area or as .691 plus 5. This last reciprocal ratio, .5, is half of unity, or 1., and is equal to two squares. The square root of 4 is 2 and the resultant area is equal to two squares. .5 is the reciprocal of root-four. .5 plus .191 equals .691 or a square plus a root-five rectangle. (.691 is the reciprocal of 1.4472.)

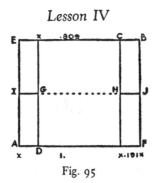

Fig. 95

AB in Fig. 95 is a 1.191 rectangle and AC is an applied square. AC equals 1 and CF equals .191. DB is an applied square to the other end of the rectangle. It overlaps the first square to the extent of the area DC. This overlap is equal to the square AC minus the area ED or .191. The fraction .191 subtracted from 1, or AC, equals .809. The area DC consequently is an .809 area and is composed of two whirling square rectangles, DH and GC. If the line GH is produced to I and J, the areas ED and CF are bisected and EG, GA, CJ and HF are .382 rectangles.

LESSON V

Further Analyses of the Square.

APPLY to a square a whirling square rectangle, Fig. 96, (for method, see Fig. 87, Lesson III).

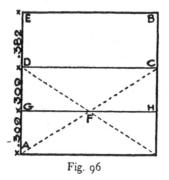

Fig. 96

AB is the square and AC the whirling square rectangle. EC is the excess area, F is the center of the whirling square area.

Draw the line GH, parallel to the base of the square, and through the point F. ED is equal to .382, DG to .309 and GA to .309. EG is equal to .691, or .309 plus .382. The area GB is a .691 or a 1.4472 rectangle within a square. The reciprocal of 1.4472 is .691.

In Fig. 97, GB is a .691 rectangle applied to the square AB. Apply a square on either end of this shape, as GI, JB. They overlap to the extent of the area JI.

If EG, Fig. 97, be considered as unity, EK is .4472, IB is .4472 and KI is .5528. EJ, LB are root-five rectangles and KL is a 1.809 rectangle. .5528 is the reciprocal of 1.809 and .809 is equal to 1.618 divided by 2. Determine the square in the 1.809 rectangle. It is MI. The area ML is composed of two whirling square rectangles. EM and NB are

94

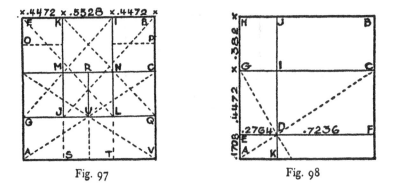

Fig. 97 Fig. 98

each double whirling square rectangles. GN, MQ are each root-five rectangles. EN is a 1.809 area, as is also MB. ES, TB are each double whirling square rectangles or each is equal to a root-five rectangle plus a square. SL is equal to JN and MT or SN is a whirling square area. SQ, GT are each root-five rectangles. AM and NV are each composed of two squares.

Apply to a square a whirling square rectangle, as AC in AB, Fig. 98, and through an intersection of a diagonal of a reciprocal and a diagonal of a whole, as D, draw the line EF. The area EC will be a root-five rectangle. HG will be .382, GE .4472 and EA .1708. HG and GE added equal .8292 (more correctly .82918). .8292 is the reciprocal of 1.206. ED measures .2764 and this multiplied by 3 equals .8292. The area HD, therefore, is composed of three squares.

DF measures .7236; FB .8292. DB is a 1.146 rectangle, or .382 multiplied by 3. HI measures .2764 by .382. The lesser into the greater supplies a 1.382 rectangle. AJ, .2764 by 1, is a 3.618 rectangle. AF, .1708 by 1, is a 5.8541 shape. KF, .1708 by .7236, is a 4.236 rectangle, or a root-five rectangle plus two squares. Its reciprocal is .236. KB, .7236 by 1, is a 1.382 shape. KC, .618 by .7236, is a 1.1708 shape and its reciprocal is .8541. IB, .382 by .7236, is a 1.8944 area, or a square plus two root-five areas.

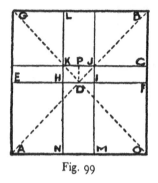

Fig. 99

Apply the whirling square rectangle AC to the square AB, Fig. 99. Find the center of the square and draw the line EF, cutting the square into two parts. GD, DB are each squares.

In the whirling square rectangle AC the applied squares are AJ and KO. The area LM is a 4.236 area and its reciprocal is .236. NM measures .236.

EP, PF are each 4.236 areas. KD, DJ are squares and EK, JF are each double whirling square rectangles.

GH and IB are each 1.309 areas, composed of the squares GK, JB and the double whirling square rectangles EK, JF.

GN, MB and GC are .382 or 2.618 areas. Other areas may be figured easily by the student. It is desirable that all the subdivisional areas be drawn to a fairly large scale and inspected carefully, as they all appear frequently in Greek design and in nature.

To the square AB, Fig. 100, apply the whirling square rectangle AC and through the intersection of its diagonals with diagonals of its reciprocals draw the line DE.

FI measures .382 and ID .1708. Adding these we have .5528 for the line FD. As mentioned above, .5528 is the reciprocal of 1.809. This area is FE and JE is its square. DJ equals two whirling square areas, GJ and GH. AE is a root-five rectangle.

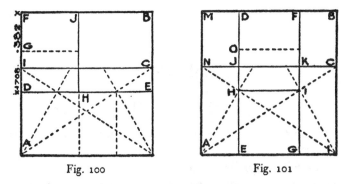

Fig. 100 Fig. 101

In the square AB, Fig. 101, apply the whirling square, rectangle AC and through the intersection of its diagonals with diagonals of its reciprocals, as H, I, draw the lines DE and FG.

The area DG or EF is a root-five rectangle and HG is its square. HF is composed of the two whirling square areas OI and OF.

EG measures .4472 and AE and GL each .2764. AD and FL are each 3.618 areas. AJ, KL are root-five rectangles and MJ, KB are each 1.382 areas. JB and MK are each 1.8944 areas, *i.e.*, are composed of a square plus two root-five shapes. MH, IB are each composed of two squares. NG, EC are each 1.17082 areas.

LESSON VI

The Addition of Unity to Dynamic Areas.

THE addition of unity or some multiple of unity, such as a square or two squares, to the areas of dynamic symmetry, is frequently found in Greek design. These additions result in a transformation of the original shape in such a manner that the new area may be subdivided to produce schemes differing entirely from the subdivisions of the original area.

In Lesson 4, we considered a 1.191 rectangle and a rather obvious method of subdivision. If we add unity or a square to the 1.191 area the resulting ratio is 2.191.

The student should remember that often many methods of subdividing the same dynamic rectangle are possible and that each method produces its own peculiar arrangement of form. Also, two rectangles of the series may be very close to the same ratio. Regarded as simple rectangles it may be impossible to tell, without measurement, which is which; yet when each is subdivided in its own terms, confusion is impossible for the reason that the subdivided arrangements are totally unlike.

Fig. 102

AB, Fig. 102, is a 2.191 rectangle. If we apply to this area a 1.382 shape the excess area is composed of two whirling squares or the reciprocal area .809. AC is a 1.382 rectangle and CD the .809 form.

Fig. 103

A 1.382 rectangle is constructed geometrically by first applying to a square a whirling square rectangle, as AC in AB, Fig. 103. .618 subtracted from unity or a square leaves a .382 area, CD. The area BE is equal to CD and AF is a 1.382 rectangle.

If a 1.382 rectangle be divided by 2, as in Fig. 104, the result is two .691 reciprocal ratios or two squares and two root-five rectangles.

S	S	.854+	
√5	√5	2.618	
.691	.691		

Fig. 104

AB is a 1.382 area; AC, CF two .691 areas, AE two squares and DB two root-five rectangles. AG is a 2.191 area and FG an .809 shape. AD measures .691 because it is equal to the length CB. If DE is continued to H the area BH is defined. This area will measure .309 by .809 and the resulting ratio will be 2.618. FG is an .809 area and FH measures .691 by .809, the ratio being either 1.17082 or .8541, depending on whether we divide .809 by .691 minus, or the reverse.

We may obtain this result in another way. The area FG may be regarded as an .809 or a 1.236 rectangle, each being composed of two whirling square rectangles. If we subtract the area EG from FG we must use the reciprocal of 2.618, *i.e.*, .382. When .382 is subtracted from 1.236 we have left .854.

If to a 2.191 rectangle we apply a 1.309 area the excess is .882, Fig. 105.

Fig. 105

A 1.309 rectangle is made by construction as follows: AC, Fig. 105, is a square and DC is an applied whirling square rectangle, the end of which measures .618, *i.e.*, the line DG. .309 is equal to one-half .618, or the area EC. The shape CF is equal to EC and AH is a 1.309 rectangle. FB is an .882 area. This latter area is equal to 5 plus .382 or two squares plus a 2.618 rectangle. AJ is a .382 area because it is the difference between .618 and 1, or the square AC. The area JE is .309 and .309 plus .382 equals .691, or a square plus a root five shape. The area KF is equal to .309 plus .309 or .618. The two reciprocal ratios, .691 and .618, added equal 1.309.

If to the whirling square rectangle AB of Fig. 106, the square AC is applied, DC measures .618 and CB .382. The line FC produced

Fig. 106

to G divides the .882 area DE into the two figures DG and BG. The area DG measures .618 by .882 and produces the ratio 1.427. BG measures .382 by .882 and the ratio is 2.309.

If the line CF be continued to H, the area HI, .382 by .691, is a 1.809 rectangle, and JF, .618 by .691, has the ratio 1.118, or two root-five rectangles, one being over the other.

LESSON VII

The Gnomon.

AFTER becoming more or less familiar with the simple bases of dynamic symmetry and, possibly, using them synthetically in design, occasions will frequently arise wherein the student will find it necessary to use an analytical method to determine the nature of unknown areas. There is a vast difference between synthesis and analysis. In the former, given a reasonable equipment for a journey, we advance freely in the direction of our goal. In the latter the objective is unknown and the finding of a solution to a puzzle or the picking up of a cold trail are matters which may tax ingenuity to its utmost. It is in analysis that the great value of simple arithmetic is proven— without its assistance the task of unraveling a design plan would be practically impossible. The function of arithmetic in this connection is twofold; it straightens out entanglements and furnishes positive proof of correctness of results.

Mathematicians have frequently asked the writer why he doesn't use algebraic symbols. The answer is simple; symmetry is immediately connected with design and design depends to a great extent on similarity of figure; *i.e.*, figures of the same shape but not necessarily of the same size; or figures of different shapes but belonging to a specific sequence of theme.

If we used algebraic symbols for the units of dynamic symmetry we should have too great a confusion of values within a specific design example. Moreover, the average designer or the average layman is not sufficiently familiar with the processes of either algebra or geometry and to use mathematical formulae would result in placing design knowledge beyond the reach of those most interested in the subject.

When we are confronted with the problem of determining the nature of unknown areas we may have recourse to several methods of analysis. If we have used a dynamic base for the development of a

design we may be assured, if our procedure has been consistent, that the subdivisions of that area are dynamic whether or not we are able to define their composition. If the unknown area is not recognizable as being composed of two or more familiar areas we may determine its reciprocal, or, if the ratio is less than unity, find the ratio of which it is the reciprocal; having fixed the reciprocal we may examine the excess or defect area: the logical position of a reciprocal is as an area, similar to the whole, applied to the end of a rectangle: we may turn the reciprocal sidewise and consider it as a subdivision of a square: we may apply it to the side of an overall area exactly as we should apply a square, and then analyze the excess area: we may apply a square or squares, or other known areas, and again examine the excess or defect.

Suppose we select some rectangle with which we are familiar and use a process of subdivision with which we are unfamiliar. Let the area be that of a 1.309 shape. Fig. 107 is such an area.

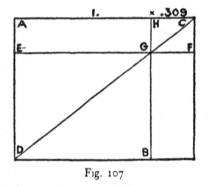

Fig. 107

It is composed of the square AB and the excess area BC. Suppose we draw the diagonal DC. It cuts HB, the side of the square AB, at G. The line EF is drawn through G. The major area is now subdivided into the minor areas AG, GC, DG and BF. This process of subdividing an area is one of the oldest known. It is practically the base of the second book of Euclid, and, by authorities, is generally conceded to be an Egyptian method of figure dissection. The right angle shaped figure ECB is known as a gnomon or carpenter's square.

It is that figure which, added to a figure, increases the size of the latter but maintains its original shape. The figure DG is similar to the figure DC. The area AG is equal to the area BF, and these two shapes are known as complements. The area GC is similar to the area DG. The simple geometric proof that AG is equal in area to BF is shown in Fig. 108.

Fig. 108

AB is a rectangle composed of the two right angled triangles ACD and CBD. They are equal in area because each represents half of the rectangle AB. CE and ED are similar figures to the whole; because they are composed of similar and equal triangles they may be cancelled. The area AE must equal the area EB because ACD is similar and equal to CBD.

Some have called this the theorem of the gnomon. The word gnomon also means "that by which something is known." Later, in classic Greek days, the name gnomon was given to the upright shadow caster of a sun-dial. We may continue the analysis.

We have decided that Fig. 107 is a 1.309 rectangle and AB is an applied square on the end. BC is the excess area. The line EG fixes the area EB, a similar figure to the whole, within the square AB. But the area EB is the reciprocal of the area of the whole. (Reference to Lesson 5, Part I, wherein the different methods for determining reciprocals are explained, will make this point clear.) If the area EB is revolved until it is at right angles to its present position and the line GB coincides with the line AH, the diagonal DG will cut the

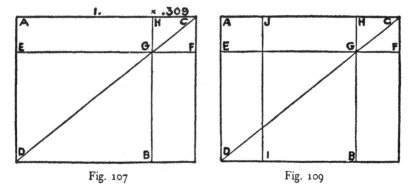

Fig. 107 Fig. 109

diagonal DC at right angles. The numerical value of the end of a reciprocal to a 1.309 rectangle is .764, minus. If AD equals unity, ED equals .764 and AE equals 1 minus .764, or .236.

The area AF measures .236 by 1.3090 and produces the ratio 5.546—for a more exact determination of this ratio we divide 1.309017 by .23606 and obtain 5.5452; for convenience we fix the ratio as 5.545, *i.e.*, five squares plus the fraction .545. We obtain the extension of the fraction of a ratio by extending the fraction of the square root of 5. To the fifth decimal this is 2.23606. This gives us .618034 for the reciprocal of a whirling square rectangle, and by dividing this by two, we obtain 1.309017 for the 1.3090 rectangle. The area BC measures .3090 by 1 and fixes the ratio 3.236 or 1.618 multiplied by 2, *i.e.*, two whirling square rectangles. The area AG, .236 by 1, is a 4.236 area.

In Fig. 109, DC is a 1.3090 rectangle; AB, IC are squares applied on either end. They overlap to the extent of the area IH. The line DB equals 1 and DI .3090; consequently the line IB equals .691: BH equals 1. The area IH, therefore, is composed of a square plus a root-five rectangle,—.691 is the reciprocal of 1.4472. The line IB equals .691 and BG .764; the area IG therefore is a 1.1056 rectangle. This ratio will readily be recognized by its reciprocal, 9045. The area JG, .236 by .691, is a 2.927 rectangle—.927 equals .3090 plus .6180. The area BF, .3090 by .764, is a 2.472 rectangle or a shape composed of four whirling square areas,—.618 multiplied by 4 equals 2.472.

LESSON VIII

Ratios Most Frequently Used, Their Reciprocals and Simple Divisions.

THE following are some of the dynamic ratios which are most frequently found not only in nature but in Greek design: (See Figs. 110 and 111).

Ratio	Reciprocal	½ Ratio	½ Reciprocal
1.118	.8944	.559	.4472
1.191	.8396	.5955	.4198
1.236	.809	.618	.4045
1.309	.764	.6545	.382
1.382	.7236	.691	.3618
1.4472	.691	.7236	.3455
1.618	.618	.809	.309
1.809	.5528	.9045	.2764
1.854	.5393	.927	.2696
2.236	.4472	1.118	.2236

The 1.118 ratio represents one-half of a root-five area, 2.236 divided by 2. It may be remembered as two root-five rectangles, one on top of the other. .8944, its reciprocal, i.e., 1.118 divided into 1, equals two root-five rectangles standing side by side. .559, being one-fourth of root-five and one-half of 1.118, is equal to four root-five rectangles placed on top of one another. It is the reciprocal of 1.7888, or .4472 multiplied by 4. .4472, one-half of .8944, is equal to one fifth of root-five, i.e., it is the reciprocal shape of that area.

The ratio 1.191 may be identified by its relation to 1.382 and .809. The fraction .191 is equal to .382 divided by 2. If .382 is subtracted from 1.191 the remainder is .809. If .191 be added to 1.191 the result

is 1.382. .8396 is the reciprocal shape of 1.191. The fraction .5955 added to .4045 equals 1 or unity. The fraction .4198 is the reciprocal of 2.382.

The ratio 1.236 is equal to .618 multiplied by 2, or root-five, 2.236, minus 1. It is composed of two whirling square rectangles standing side by side. Its reciprocal .809 is also equal to two whirling square rectangles, one on top of the other. .809 is equal to 1.618 divided by 2. The .618 rectangle has been explained. If .809 is equal to two whirling square rectangles one above the other, the fraction .4045 is equal to four such shapes in the same position. Multiplied by four this fraction equals 1.618.

The ratio 1.309 is equal to a square plus two whirling square rectangles placed end to end. The fraction .309 is equal to .618 divided by 2. The reciprocal .764 is equal to .382 multiplied by 2. The difference between .764 and unity or 1 is .236, and this fraction represents the difference between root-four and root-five, 2 and 2.236. The fraction .6545, *i.e.*, one-half of 1.309, is composed of two squares plus four whirling square rectangles, *i.e.*, .5 plus .1545—unity divided by 2 and .309 divided by 2. The fraction .6545 is the reciprocal of 1.5278, or 1.528 for short. If .6545 be subtracted from unity the remainder is .3455 or .691 divided by 2. The difference between .691 and unity is .309. The fraction .3455 is the reciprocal of 2.8944, *i.e.*, two squares and two root-five rectangles. The fraction .382 is the reciprocal of 2.618, or a square plus a whirling square rectangle.

The ratio 1.382 is equal to a square plus a 2.618 shape. The fraction .382 will be recognized as the difference between .618 and unity. The reciprocal ratio .7236 multiplied by 2 equals a square plus a root-five rectangle, *i.e.*, 1 plus .4472. The difference between .7236 and unity is .2764. Dividing .7236 by 2 we get .3618. The fraction .2764 is the reciprocal of 3.618, and .3618 is the reciprocal of 2.764 or 1.382 multiplied by 2, or .691 multiplied by 4.

Diagrams for pages 105–106

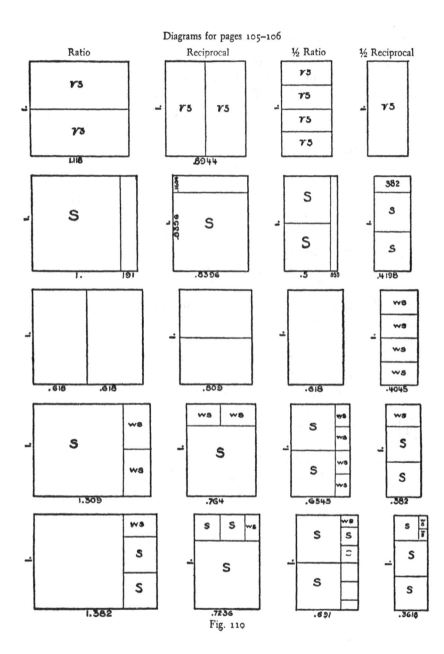

Fig. 110

The ratio 1.4472, a square plus a root-five rectangle, is one of the most important of the modulating forms of dynamic symmetry. Dividing the ratio by 2 we obtain .7236, the reciprocal of 1.382. The difference between .4472 and unity is .5528, or the reciprocal of 1.809. Multiplied by 2 the ratio 1.4472 equals 2.8944. The fraction .4472 multiplied by 2 equals .8944, the reciprocal of 1.118. The reciprocal .691 multiplied by 2 equals 1.382. The difference between .691 and unity is .309.

The ratio 1.618, its reciprocal .618 and the connection of both with the square root of five have been described in previous lessons.

The ratio 1.809 is composed of a square plus two whirling square rectangles, these latter being placed one over the other. The fraction .809 is equal to 1.618 divided by 2. If we add .191 to 1.618 the result is 1.809. The difference between the reciprocal .5528 and unity is .4472. The fraction .9045 is equal to .5 plus .4045, or two squares plus four whirling square rectangles. The difference between .2764 and unity is .7236 (see above). The difference between 1.382 and 1.809 is .427; between 1.809 and root five, *i.e.*, 2.236, is .427. A very engaging scheme and apparently a popular one with the Greeks.

The ratio 1.854 is equal to .618 multiplied by 3. If the fraction .854 be divided by 2 the result is .427. If the reciprocal .5393 be multiplied by 2 the result is 1.0786, the reciprocal of which is .927, this being composed of .618 plus .309. The fraction .2696 is the reciprocal of 3.708 or .618 multiplied by 6.

The ratio 2.236, *i.e.*, the square root of five, its reciprocal .4472 and many modulating subdivisions of the area, have frequently been described.

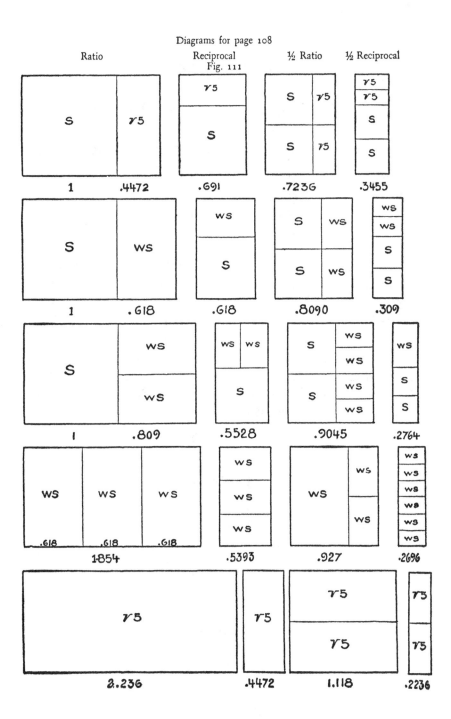

Diagrams for page 108

| Ratio | Reciprocal Fig. 111 | ½ Ratio | ½ Reciprocal |

LESSON IX

Ratios Most Frequently Used, Their Reciprocals and Simple Divisions.

Ratio	Reciprocal	½ Ratio	½ Reciprocal
2.309	.433	1.1545	.216
2.4472	.408	1.2236	.204
2.472	.4045	1.236	.202
2.618	.382	1.309	.191
2.764	.3618	1.382	.1809
2.809	.3559	1.4045	.1779
2.8944	.3455	1.4472	.1727
3.236	.309	1.618	.1545
3.427	.2918	1.7135	.146
3.618	.2764	1.809	.1382

THE ratio 2.309 will be recognizable as 1.309 plus a square; or .309 plus two squares. The fraction .309 is identified as half of .618. In diagram form this fraction is simply one whirling square rectangle over another, end to end, as in Fig. 112.

.309

Fig. 112

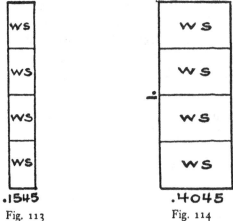

Fig. 113 Fig. 114

If this ratio is divided by two the result is represented diagrammatically by one square plus four whirling square rectangles standing end to end on top of each other, and the new ratio is 1.1545. The .1545 part is shown in Fig. 113.

If these four shapes were placed on top of each other, side to side, as is shown in Fig. 114, they would be represented by the reciprocal ratio .4045, *i.e.*, one-fourth of 1.618.

Of course the 2.309 area may be divided in many other ways, but the one described is the direct or simple subdivision.

It will prove instructive to the student to work out the following subdivisions of the 2.309 shape:

.382	plus	1.927	equals	2.309	
.500	"	1.809	"	"	
.618	"	1.691	"	"	
.764	"	1.545	"	"	
.691	"	1.618	"	"	
.809	"	1.500	"	"	
.882	"	1.427	"	"	
.927	"	1.382·	"	"	
.8944	"	1.4146	"	"	
1.118	"	1.191	"	"	
1.236	"	1.073	"	"	
1.382	"	.927	"	"	etc., etc.

The ratio 2.4472, *i.e.*, two squares plus the root-five reciprocal .4472, may be subdivided by any dynamic combination which equals two; the .4472 area will take care of itself in such combinations. In its simplest form it is composed of a square plus a square and a root-five area, *i.e.*, 1 plus 1.4472. We may have combinations like the following:

.1382	plus	2.309	equals	2.4472	
.8944	"	1.5528	"	"	
1.309	"	1.1382	"	"	
1.618	"	.8292	"	"	
1.7236	"	.7236	"	"	
1.8944	"	.5528	"	"	
2.0652	"	.382	"	"	
2.1708	"	.2764	"	"	etc., etc.

The ratio 2.472 occurs frequently in Greek design. It is easily recognizable as .618 multiplied by four, or 1.236 multiplied by 2. Other combinations are:

1.382	plus	1.090	equals	2.472	
1.545	"	.927	"	"	
1.618	"	.854	"	"	
1.708	"	.764	"	"	
1.927	"	.545	"	"	
2.045	"	.427	"	"	
2.236	"	.236	"	"	etc., etc.

The most natural subdivision of the 2.618 area is that of a square plus a whirling square rectangle. Other arrangements or composing elements of this shape are: (p. 114)

Diagrams for pages 110–114

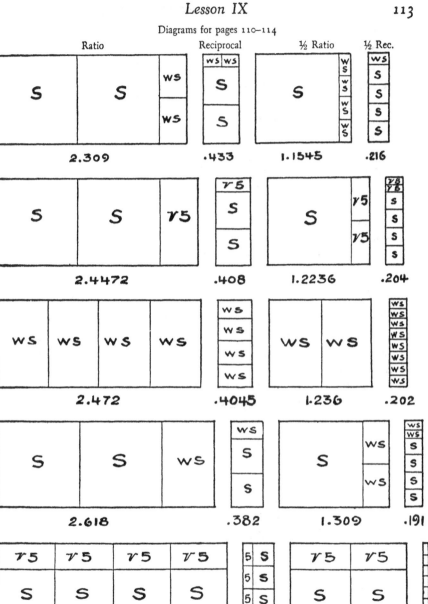

Fig. 115

1.309	plus	1.309	equals	2.618
1.382	"	1.236	"	"
1.427	"	1.191	"	"
1.4472	"	1.1708	"	"
1.472	"	1.146	"	"
1.528	"	1.090	"	"
1.691	"	.927	"	"
1.7236	"	.8944	"	"
1.764	"	.854	"	"
1.809	"	.809	"	"
1.854	"	.764	"	"
2.000	"	.618	"	"
2.236	"	.382	"	"
2.309	"	.309	"	"
2.4472	"	.1708	"	"
2.472	"	.146	"	" etc., etc.

The 2.618 ratio is one of the most engaging of the dynamic series. It is, apparently, closely connected with the leaf distribution phenomena. Also, it is the square of 1.618, *i.e.*, this latter ratio multiplied by itself equals 2.618.

The 2.764 area will readily be recognized if divided by 2. This operation cuts it into two 1.382 shapes. Some of its composing units are:

1.382	plus	1.382	equals	2.764
1.472	"	1.292	"	"
1.528	"	1.236	"	"
1.691	"	1.073	"	"
1.764	"	1.000	"	"
1.809	"	.955	"	"
1.854	"	.910	"	"
2.000	"	.764	"	"
2.236	"	.528	"	"
2.309	"	.455	"	"
2.472	"	.292	"	"
2.618	"	.146	"	" etc., etc.

Diagrams for page 110

Fig. 116

Frequently it is necessary to construct odd compound rectangles within a square, especially so when turning corners. The simplest and most direct method for this purpose is that of constructing the required figure, minus a square, outside a square, and then drawing a diagonal to the entire area. For example, if it is required to fix a 2.309 rectangle within a square the process is to draw a 1.309 shape outside a square as in Fig. 117.

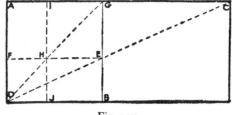

Fig. 117

AB is a square and BC a 1.309 rectangle. DC is a diagonal to a 2.309 area; *i.e.*, 1.309 plus 1. This diagonal cuts a side of the square AB at E. Draw FE parallel to DB. The area DE is a 2.309 rectangle within the square AB, *i.e.*, DE is the reciprocal of DC.

The nature of the area AE is found when we fix the numerical value of the line FD. This is .433 or the reciprocal of 2.309. The line AD equals 1, FD .433 and AF the difference between .433 and unity or .567; this is a reciprocal ratio, being that of 1.764. The fraction .764 is the reciprocal of 1.309. Therefore the area AE is equal to a square, HG, and a 1.309 rectangle, AH.

AJ is a 2.309 area, being the reciprocal of DC. If the square DH is subtracted from AJ then AH equals 1.309. JG is a similar figure to AE and JE is similar to AH.

We frequently find in Greek design curious compound figures such as 1.691. This ratio, for example, is composed of a square plus a square and a root-five rectangle, .691 being the reciprocal of 1.4472. If we had a plan wherein .691 areas were arranged along the bounding lines of a dynamic area as in Fig. 118, AB might be such a rectangle, DC and EF .691 rectangles.

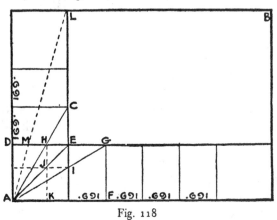

Fig. 118

AC and AG are diagonals to 1.691 rectangles, AH and AI are 1.691 areas within the square AE, and DJ, KI are .691 shapes. AJ, JE are squares. AL is composed of two 1.691 areas or 3.382. If we draw a line from A to L it cuts DE at M. The area AM is a 3.382 rectangle and the reciprocal of AL.

If we wish to determine a 2.4472 area inside a square we construct a 1.4472 area outside the square and draw a diagonal to the whole.

Angle square	Area outside	Resulting ratios	
1	1.618	2.618	
1	.691	1.691	
1	.7236	1.7236	
1	.764	1.764	
1	.809	1.809	
1	1.809	2.809	
1	2.809	3.809	
1	1.191	2.191	
1	2.191	3.191	etc., etc.

WHAT INSTRUMENTS TO USE AND
HOW TO USE THEM

The implements necessary for a careful study of the shapes of dynamic symmetry are: a scale divided into millimeters, or a foot-rule divided into tenths, a small drawing board, one that is perfectly true, a T-square, a compass, and a lead pencil.

The student is advised, whenever possible, to construct the rectangles both geometrically and arithmetically. The diagrams of the lessons show how the geometrical constructions are made. For the arithmetical constructions the scale is used.

The first step is the establishment of a right angle with the T-square. Measure off on one of the lines 100 millimeters or 10 centimeters, or whatever is the unit of measurement which has been selected, and call this unity; if a whirling square rectangle is desired measure off on the other line 161.8 millimeters or 16.18 centimeters. If 100 millimeters or 10 centimeters is assumed to be unity, or the short side of the rectangle, then the reading is 1. or unity plus .618 parts of unity or 1.618, for the long side. A little practice will enable the student to construct any rectangle from its ratio with great rapidity.

A 1.809 rectangle is simply one part in one direction and 1.809 parts in the other, the shapes being completed with the T-square from the two measurements. A root-five rectangle is one part one way and 2.236 the other; a 1.309 shape, one part one way and 1.309 the other.

Reciprocal ratios are always less than unity, a reciprocal being obtained by dividing the ratio into unity. The reciprocal of root-five is .4472. To draw this by scale mark off one part one way and .4472 the other, that is, unity is now the long side of the rectangle and

.4472 the short side. The reciprocal of a whirling square rectangle is .618; measure off one part one way and .618 the other. The reciprocal of a 1.309 shape is a very small amount less than .764; scale off one part one way and .764 the other. The reciprocal of a 1.809 shape is a little less than .528; scale off one part one way and .528 the other.

Having a ratio the construction is always simple. To obtain a ratio measure the greatest height and the greatest width, whatever the object may be, and divide the lesser into the greater. Dividing the greater into the lesser has the same effect as dividing a ratio into unity to obtain a reciprocal. For example, if an object being examined measures 320 one way and 4188 the other, the greater measurement being divided into the lesser, the answer is .764. If the lesser is divided into the greater it is 1.309; if the ratio 1.309 is divided into unity the answer is .764. In either case the result is a 1.309 rectangle, the question being one of relationship.

To find the length of an area, the desired width having been selected, multiply the ratio by the width. For example, if the selected width is 3 feet, or 3 decimeters, and the ratio desired is a root-five rectangle, the length will be 6.708 or 2.236 multiplied by 3. Inversely 6.708 divided by 3 equals 2.236.

DEFINITIONS *

A *point* has position, but it has no magnitude.

A *line* has position, and it has length, but neither breadth nor thickness.

A *straight line* is a line which lies evenly with the points on itself.

A *curved line*, or a *curve*, is a line of which no part is straight.

A *surface* (or superfices) has position, and it has length and breadth, but not thickness.

A *plane surface* is a surface which lies evenly with the straight lines on itself.

When two straight lines are drawn from the same point, they are said to contain a *plane angle*. The straight lines are called the *arms* of the angle, and the point is called the *vertex*.

The *bisector* of an angle is the straight line that divides it into two equal angles.

When a straight line stands on another straight line, and makes the adjacent angles equal to each other, each of the angles is called a *right angle*; and the straight line which stands on the other is called a *perpendicular* to it.

An *obtuse* angle is one which is greater than a right angle.

An *acute* angle is one which is less than a right angle.

When two straight lines intersect each other, the opposite angles are called *vertically opposite angles*.

Parallel straight lines are such as are in the same plane, and being produced ever so far both ways do not meet.

A *figure* is that which is inclosed by one or more boundaries; and a *plane figure* is one bounded by a line or lines drawn upon a plane.

The space contained within the boundary of a plane figure is called its *surface*; and its surface in reference to that of another figure, with which it is compared, is called its *area*.

* Selected from *The Thirteen Books of Euclid's Elements* by T. L. Heath and *The Elements of Euclid* by John Sturgeon Mackay.

A *circle* is a plane figure contained by one (curved) line which is called the *circumference*, and is such that all straight lines drawn from a certain point within the figure to the circumference are equal to one another. This point is called the *centre* of the circle.

A *radius* (plural, *radii*) of a circle is a straight line drawn from the centre to the circumference.

A *diameter* of a circle is a straight line drawn through the centre, and terminated both ways by the circumference.

Rectilineal figures are those which are contained by straight lines.

The straight lines are called *sides*, and the sum of all the sides is called the *perimeter* of the figure.

Rectilineal figures contained by three sides are called *triangles*.

Rectilineal figures contained by four sides are called *quadrilaterals*.

Rectilineal figures contained by more than four sides are called *polygons*.

An *equilateral* triangle is one that has three equal sides.

An *isosceles* triangle is one that has two equal sides.

A *scalene* triangle is one that has three unequal sides.

A *right-angled* triangle is one that has a right angle.

An *obtuse-angled* triangle is one that has an obtuse angle.

An *acute-angled* triangle is one that has three acute angles.

Any side of a triangle may be called the *base*. In an isosceles triangle, the side which is neither of the equal sides is usually called the *base*. In a right-angled triangle, one of the sides which contain the right angle is often called the *base*, and the other the *perpendicular*; the side opposite the right angle is called the *hypotenuse*.

Any of the angular points of a triangle may be called the *vertex*. If one of the sides of a triangle has been called the base, the angular point opposite that side is usually called the vertex.

A *rhombus* is a quadrilateral that has all its sides equal.

A *square* is a quadrilateral that has all its sides equal, and all its angles right angles.

A *parallelogram* is a quadrilateral whose opposite sides are parallel.

A *rectangle* is a quadrilateral whose opposite sides are parallel, and whose angles are right angles.

A *trapezium* is a quadrilateral that has two sides parallel.

A *diagonal* of a quadrilateral is a straight line joining any two opposite corners.

Book II.

Any rectangular parallelogram is said to be *contained* by the two straight lines containing the right angle.

And in any parallelogrammic area let any one whatever of the parallelograms about its diameter with the two complements be called a *gnomon*.

Book III.

Equal circles are those the diameters of which are equal, or the radii of which are equal.

A straight line is said to *touch* a circle, or be a *tangent* to it, when it meets the circle, but being produced does not cut it.

Circles which meet but do not cut one another, are said to *touch* one another.

The points at which circles touch each other, or at which straight lines touch circles, are called *points of contact*.

An *arc* of a circle is any part of the circumference.

A *segment of a circle* is the figure contained by a straight line and a circumference of a circle.

An *angle of a segment* is that contained by a straight line and a circumference of a circle.

A *sector* of a circle is the figure which, when an angle is constructed at the centre of the circle, is contained by the straight line containing the angle and the circumference cut off by them.

Book IV.

A rectilineal figure is said to be *inscribed* in a rectilineal figure when the respective angles of the inscribed figure lie on the respective sides of that in which it is inscribed.

A rectilineal figure is said to be *inscribed* in a circle when each angle of the inscribed figure lies on the circumference of the circle.

A circle is said to be *inscribed* in a figure when the circumference of the circle touches each side of the figure in which it is inscribed.

Book V.

A magnitude is a *part* of a magnitude, the less of the greater, when it measures the greater.

Ratio is a relation of two magnitudes of the same kind to one another, in respect of quantiplicity (a word which refers to the number of times or parts of a time that the one is contained in the other). The two magnitudes of a ratio are called its *terms*. The first term is called the *antecedent*; the latter, the *consequent*.

Magnitudes are said to *have a ratio* to one another which are capable, when multiplied, of exceeding one another.

Magnitudes are said to be *proportionals* when the first has the same ratio to the second that the third has to the fourth; and the third to the fourth the same ratio which the fifth has to the sixth; and so on, whatever be their number.

When four magnitudes are proportional, they constitute a *proportion*. The first and last terms of the proportion are called the *extremes*; the second and third, the *means*.

When there is any number of magnitudes greater than two, of which the first has to the second the same ratio that the second has to the third, and the second to the third the same ratio which the third has to the fourth, and so on, the magnitudes are said to be *continual proportionals*, or *in continued proportion*.

When three magnitudes are in continued proportion, the second is said to be a *mean proportional* between the other two.

A ratio which is compounded of two equal ratios is said to be *duplicate* of either of these ratios.

A ratio which is compounded of three equal ratios is said to be *triplicate* of any one of these ratios.

Book VI.

Similar rectilineal figures are such as have their angles severally equal and the sides about the equal angles proportional.

A straight line is said to be cut in *extreme and mean ratio* when the whole line is to the greater segment as the greater segment is to the less.

The *height* of any figure is the perpendicular drawn from the vertex to the base.

Book VII.

An *unit* is that by virtue of which each of the things that exist is called one.

A *square number* is equal multiplied by equal, or a number which is contained by two equal numbers.

A *cube* is equal multiplied by equal and again by equal, or a number which is contained by three equal numbers.

Numbers are *proportional* when the first is the same multiple, or the same part, or the same parts, of the second that the third is of the fourth.

Similar plane and *solid* numbers are those which have their sides proportional.

A *perfect number* is that which is equal to its own parts.

Book X.

Those magnitudes are said to be *commensurable* which are measured by the same measure, and those *incommensurable* which cannot have any common measure.

Straight lines are *commensurable in square* when the squares on them are measured by the same area; and *incommensurable in square* when the squares on them cannot possibly have any area as a common measure.

With these hypotheses, it is proved that there exist straight lines infinite in multitude which are commensurable and incommensurable respectively, some in length only, and others in square also, with an assigned straight line. Let then the assigned straight line be called *rational*, and those straight lines which are commensurable with it, whether in length and in square or in square only, *rational*, but those which are incommensurable with it *irrational*.

And let the square on the assigned straight line be called *rational* and those areas which are commensurable with it *rational*, but those which are incommensurable with it *irrational*, and the straight lines which produce them *irrational*, that is, in case the areas are squares, the sides themselves, but in case they are any other rectilineal figures, the straight lines on which are described squares equal to them.

Book XI.

A *solid* is that which has length, breadth, and thickness.

A *pyramid* is a solid figure, contained by planes, which is constructed from one plane to one point.

A *cube* is a solid figure contained by six equal squares.

A *tetrahedron* is a solid figure contained by four equal triangles.

An *octahedron* is a solid figure contained by eight equal and equilateral triangles.

An *icosahedron* is a solid figure contained by twenty equal and equilateral triangles.

A *dodecahedron* is a solid figure contained by twelve equal, equilateral, and equiangular pentagons.

GLOSSARY

Angiosperm (Gk. *aggeion*, a vessel, and *sperma*, a seed), a plant whose seeds are contained in a protecting seed vessel.

"Apply" an area—"For, when you have a straight line set out and lay the given area exactly alongside the whole of the straight line, then they say that you *apply* the said area; when, however, you make the length of the area greater than the straight line itself, it is said to *exceed*, and when you make it less, in which case, after the area has been drawn, there is some part of the straight line extending beyond it, it is said to *fall short*."—Heath's *Euclid*, Vol. I. p. 343.

Apollo Statues.—The name 'Apollo' has been given to one of the archaic types of Greek sculpture, representing a youthful nude male figure standing in a rigidly frontal pose, with the weight equally distributed on the two legs, the left leg always being advanced, the arms held stiffly to the sides. Such figures have been found in many regions of the Greek world, often in sanctuaries of Apollo. These do not necessarily represent Apollo; they are votive offerings to the divinity, like the figures of 'maidens' found on the Athenian Acropolis, which are not identified with the goddess or with the dedicator. Others, like the 'Apollos' of Tenea, were grave monuments, ideally representing the deceased. Two colossal 'Apollos' found at Delphi represent the Argive youths Cleobis and Biton, whose story is told by Herodotus. Originated under the influence of Egyptian art, this type is the forerunner of the athletic statues of the fifth and fourth centuries B. C.

Bijugate (L. *bijugis*, yoked two together), in botany, having two pairs of leaflets.

Bract, subtending (L. *bractea*, thin plate, *subtendere*, stretch under), a leaf in a flowery cluster or subtending a flower, usually differing somewhat from an ordinary leaf in size, form, or texture, often much reduced, and sometimes petaloid, highly colored, and very conspicuous.

Circumference (L. *circum*, around, and *ferre*, to carry), encompassing boundary, especially of figure inclosed by curve, as circle.

Commensurable; among geometricians, an appellation given such quanti-
ties as are measured by one and the same common measure.

Commensurable numbers are such as can be measured or divided by some
other without any remainder: such are 12 and 18 as being measured
by 6 and 3.

Complement of a shape is that area which represents the difference be-
tween the selected figure and unity. The complement of any number
is obtained by dividing the number into unity to find the reciprocal and
subtracting that reciprocal from unity.

Compositae (L. *compositus*, put together, compound), the largest natural
order of plants, including over 750 genera and 10,000 species,
distributed all over the globe wherever vegetation is found, and di-
vided equally between the old world and the new (sunflower fam-
ily).

Corolla tubes, (L. *corona*, crown) petals fused to form a tube, as in the
blue bell.

Cube root. The cube root of a quantity is another quantity which when
multiplied by itself twice gives the original quantity; thus, 3 is the cube
root of 27 because 3 times 3 times 3 equals 27.

Delian or Duplication of the Cube Problem, in mathematics the problem
to determine the side of a cube which shall have double the solid con-
tents of a given cube. The problem is equivalent to finding the cube
root of 2, which is neither rational nor rationally expressible in terms of
square roots of integers (whole numbers); consequently neither an
exact numerical solution nor an exact construction with a rule and
compass is possible.

"Eratosthenes, in his letter to Ptolemy III., relates that one of the
old tragic poets introduced Minos on the stage erecting a tomb for his
son Glaucos; and then, deeming the structure too mean for a royal
tomb, he said 'double it but preserve the cubical form': Later (in the
time of Plato), so the story goes, the Delians, who were suffering from a
pestilence, being ordered by the oracle to double one of their altars, were
thus placed in the same difficulty. They sent therefore to the geometers
of the Academy, entreating them to solve the question. This problem
of the duplication of the cube—henceforth known as the *Delian Prob-
lem*—may have been originally suggested by the practical needs of
architecture, as indicated in the legend, and have arisen in Theocratic
times; it may subsequently have engaged the attention of the Pythag-

oreans as an object of theoretic interest and scientific inquiry."
—Allman, p. 85.

Diagonal (Gk. *dia*, through, and *gonia*, angle), straight line joining two non-adjacent angles of rectilineal figure or solid contained by planes.

Diameter (Gk. *dia*, across, and *metron*, measure), straight line passing from side to side of any body or geometrical figure through centre.

Diatoms, one-celled aquatic plants showing high degree of symmetry.

Discoid shell (Gk. *diskoeides*), disk-shaped, such as the nautilus shell.

Dynamic symmetry. As Mr. Hambidge has explained in his book "Dynamic Symmetry in Composition," he selected the term "dynamic symmetry" after studying the matter from every possible angle, as best describing the proportioning principle which he had found in the root rectangles. At the time he chose it he was unfamiliar with the Greek language and only acquired some knowledge of it on a visit to Greece after he had used the name and taught the idea for several years. Imagine his surprise when one evening, while looking up some passage in Euclid, he came across the words '*dunamei summetros*,' meaning '*commensurable in square.*' Without knowing it he had hit upon the actual expression the Greeks had used in describing the peculiar property of the root rectangles. "*Commensurable in square* is in the Greek *dunamei summetros.* In earlier translations *dunamei* has been translated '*in power*,' but, as the particular power represented by *dunamis* in Greek geometry is *square*, I have thought it best to use the latter word throughout."—Heath's *Euclid*, Vol. III, p. 11.

Euclid, author of the famous Elements, lived in Alexandria during the 3rd century B.C. Little seems to be known of his birth, life and death, but one thing is certain, that he taught, and founded a school of mathematics at Alexandria, which was at the time becoming a centre, not only of commerce, but of learning and research. It is probable that he received his mathematical training in Athens from the pupils of Plato and may himself have been a Platonist, but this does not follow from the statements of Proclus on the subject. Proclus says that he was of the school of Plato and in close touch with that philosophy.

Proclus preserves a reply made by Euclid to King Ptolemy: "they say that Ptolemy once asked him if there was in geometry any shorter way than the elements, and he answered that there was no royal road to geometry."

Another story is told of Euclid which it may not be inappropriate

to quote here:—"some one who had begun to read geometry with Euclid, when he had learnt the first theorem, asked Euclid, 'But what shall I get by learning these things?' Euclid called his slave and said 'Give him threepence, since he must make gain out of what he learns.' Pappus of Alexandria, in his Mathematical Collections, says that Euclid was a man of mild temperament, unpretending and kind to all genuine students of mathematics. This seems to be all that is known of his character."

Graph, symbolic diagram expressing system of mathematical or chemical connexion (abbreviation of *graphic formula*).

Harpedonaptae. "See Cantor (Vorlesungen über Geschichte der Mathematik, pp. 55–57), who points out the Greek origin (*arpedone*, a rope, and *aptein, to* fasten), previously overlooked, of this name, and shows from inscriptions on the Egyptian temples that the duty of these 'rope-fasteners' consisted in the orientation of the buildings by reference to the constellation of the Great Bear. The meridian being thus found, the line at right angles to it was probably determined by the construction of a triangle with ropes measuring 3, 4 and 5 lengths respectively. We have seen that the Egyptians knew that such a triangle would be right-angled. The operation of rope-stretching, Cantor adds, was one of unknown antiquity, being noticed in a record of the time of Amenemhat I., which is preserved in the Berlin Museum."—Allman, p. 218.

Hypotenuse (Gk. *hypoteino*, stretch under), side opposite right angle of triangle.

Incommensurable lines are such as have no common measure, the diagonal and side of a square are incommensurable, being to each other as root 2 to 1, and consequently whatever number of parts the side of the square may be divided into, the hypotenuse will not be made up of any exact number of parts.

Inflorescence (L. begin to blossom), a flowering, unfolding of blossoms. In botany, the arrangement of flowers on the axis and in relation to each other. Also used for flower cluster itself.

Logarithmic spiral (Gk. *logos*, reckoning, ratio and *arithmos*, number). "The name 'logarithmic spiral' is due to Jacques Bernoulli, noted Swiss mathematician of the 17th Century, who discovered the properties of the spiral. The spiral has been called also the geometrical spiral, and the proportional spiral; but more commonly, because of the prop-

erty observed by Descartes, the equiangular spiral."—"The Greek Vase," p. 146.

Module (L. *modulus*, a small measure), in architecture, a standard of measure often taken, particularly in antiquity and the Middle Ages, to regulate the proportions of an order or the disposition of an entire building.

Multijugate (L. *multus*, many and *jugum*, yoke), in botany consisting of many pair of leaflets.

Parastichy (Gk. *para*, about, and *stichos*, a row), in botany a set of secondary spirals which become apparent when leaves or scales are very crowded as in pine cones.

Perpendicular (L. *perpendiculum*, plumb-line), at right angles to plane of horizon; (Geom.) at right angles to given line, plane or surface.

Phyllotaxis (Gk. *phullon*, leaf, and *taxis*, order), in botany the distribution or arrangement of leaves on the stem, also the laws collectively which govern such distribution.

Phylogenetically (Gk. *phulon*, race, tribe, and *geneia*, producing), from standpoint of racial development.

Quadrant arc, curved line which with two radii vectors cuts off a quarter of circle's circumference.

Radiolaria, one-celled aquatic animals with highly symmetrical skeletons.

Radius vector (plural *radii*, L., ray or spoke, and *vect-*(or), carrier) of a point, in any system of polar co-ordinates, is the distance from the pole to the point.

Ratio, is a sort of relation in respect of size between two magnitudes of the same kind.

Reciprocal of a rectangle is a figure similar in shape to the major rectangle but smaller in size. The reciprocal of any number is obtained by dividing that number into 1 or unity.

Rhomboidal facets (Gk. *rhombos*, spinning top or wheel), lozenge shaped faces.

Section, the: scholars agree that "the section" refers to the division of a line in extreme and mean ratio. It has also been referred to as the "divine section," "golden section," "divine proportion."

Sine (L. *sinus*, a bend or curve), in trigonometry formerly, with reference to any arc of a circle, the line drawn from one extremity of the arc at right angles to the diameter which passes through its other extremity; now ordinarily, with reference not to the arc but to the angle which it

subtends at the centre of the circle, the ratio of the aforesaid line to the radius of the circle.

Square root of a quantity: a quantity which being taken twice as a factor, will produce the given quantity: thus, the square root of 25 is 5, because 5 times 5 equals 25. When the square root of a number can be expressed in exact parts of 1, that number is a perfect square, and the indicated square root is said to be commensurable. All other indicated square roots are incommensurable.

Sulvasutras. Among the Indian rules of ceremonials are classed the "sulvasutras," or "rules of the cord," which treat of the measurement by means of cords, and the construction of different kinds of altars required for sacrifice. These treatises are of special interest as supplying important information regarding the earliest geometrical operations in India. Along with the sutras (rules) may be classed a large number of supplementary treatises, on various subjects connected with the sacred texts and Vedic religion generally.

Summation Series. Also known as a Fibonacci series because it was first noted by Leonardo da Pisa, called Fibonacci, Italian mathematician of the 13th century. Leonardo was also distinguished as the man who introduced into Europe the Arabic system of notation.

Tenea Apollo. An archaic Greek statue in the Glyptothek at Munich, probably representing not Apollo but an athlete (see Apollo statues).

Turbinated shells (L. *turbo*, wheel, top), shaped like a top or inverted cone, such as the conch shell.

Vitruvius Pollio, Marcus, born at Verona. A famous Roman architect and engineer, military engineer under Cæsar and Augustus. His treatise on architecture, in ten books (De Architectura), dedicated to Augustus, is the only surviving Roman treatise on the subject. He seems to have been an unsuccessful architect: his book, however, was well known to Pliny, and on it was based almost all the earlier theory and practice of Renaissance and pseudo-classical architecture.

"Modern research has entirely discredited Vitruvius. Not a single Greek example has been found which bears out the Roman writer's theory. As a matter of fact, now that we have dynamic symmetry as a guide, it is clearly to be seen that this writer gives us nothing but the echo of a tradition and his elaborate instructions for constructing buildings in the Greek style constitute nothing more than the Roman method of using static symmetry. The Romans were either intention-

ally misled by the Greek artists and craftsmen, or, blinded by conceit, they jumped at the conclusion that what was meant by the Greek tradition that the 'members of the human body were commensurate with the whole' was that the length measurements were commensurate. Dynamic symmetry now shows us that not only are the members of a Greek statue of the best period commensurate with the whole, but that the same is true of the human figure. But commensurate means commensurate in area, not in line. If a statue is made wherein the members are commensurate in line a static condition necessarily results." —"The Greek Vase," Note III, p. 146.

Volute (L. *voluta*, roll), spiral scroll characteristic of Ionic, Corinthian and Composite capitals.

A CATALOG OF SELECTED
DOVER BOOKS
IN ALL FIELDS OF INTEREST

A CATALOG OF SELECTED DOVER
BOOKS IN ALL FIELDS OF INTEREST

100 BEST-LOVED POEMS, Edited by Philip Smith. "The Passionate Shepherd to His Love," "Shall I compare thee to a summer's day?" "Death, be not proud," "The Raven," "The Road Not Taken," plus works by Blake, Wordsworth, Byron, Shelley, Keats, many others. 96pp. 5³⁄₁₆ x 8¼. 0-486-28553-7

100 SMALL HOUSES OF THE THIRTIES, Brown-Blodgett Company. Exterior photographs and floor plans for 100 charming structures. Illustrations of models accompanied by descriptions of interiors, color schemes, closet space, and other amenities. 200 illustrations. 112pp. 8⅜ x 11. 0-486-44131-8

1000 TURN-OF-THE-CENTURY HOUSES: With Illustrations and Floor Plans, Herbert C. Chivers. Reproduced from a rare edition, this showcase of homes ranges from cottages and bungalows to sprawling mansions. Each house is meticulously illustrated and accompanied by complete floor plans. 256pp. 9⅜ x 12¼.

0-486-45596-3

101 GREAT AMERICAN POEMS, Edited by The American Poetry & Literacy Project. Rich treasury of verse from the 19th and 20th centuries includes works by Edgar Allan Poe, Robert Frost, Walt Whitman, Langston Hughes, Emily Dickinson, T. S. Eliot, other notables. 96pp. 5³⁄₁₆ x 8¼. 0-486-40158-8

101 GREAT SAMURAI PRINTS, Utagawa Kuniyoshi. Kuniyoshi was a master of the warrior woodblock print — and these 18th-century illustrations represent the pinnacle of his craft. Full-color portraits of renowned Japanese samurais pulse with movement, passion, and remarkably fine detail. 112pp. 8⅜ x 11. 0-486-46523-3

ABC OF BALLET, Janet Grosser. Clearly worded, abundantly illustrated little guide defines basic ballet-related terms: arabesque, battement, pas de chat, relevé, sissonne, many others. Pronunciation guide included. Excellent primer. 48pp. 4³⁄₁₆ x 5¾.

0-486-40871-X

ACCESSORIES OF DRESS: An Illustrated Encyclopedia, Katherine Lester and Bess Viola Oerke. Illustrations of hats, veils, wigs, cravats, shawls, shoes, gloves, and other accessories enhance an engaging commentary that reveals the humor and charm of the many-sided story of accessorized apparel. 644 figures and 59 plates. 608pp. 6⅛ x 9¼.

0-486-43378-1

ADVENTURES OF HUCKLEBERRY FINN, Mark Twain. Join Huck and Jim as their boyhood adventures along the Mississippi River lead them into a world of excitement, danger, and self-discovery. Humorous narrative, lyrical descriptions of the Mississippi valley, and memorable characters. 224pp. 5³⁄₁₆ x 8¼. 0-486-28061-6

ALICE STARMORE'S BOOK OF FAIR ISLE KNITTING, Alice Starmore. A noted designer from the region of Scotland's Fair Isle explores the history and techniques of this distinctive, stranded-color knitting style and provides copious illustrated instructions for 14 original knitwear designs. 208pp. 8⅜ x 10⅞. 0-486-47218-3

Browse over 9,000 books at www.doverpublications.com

ALICE'S ADVENTURES IN WONDERLAND, Lewis Carroll. Beloved classic about a little girl lost in a topsy-turvy land and her encounters with the White Rabbit, March Hare, Mad Hatter, Cheshire Cat, and other delightfully improbable characters. 42 illustrations by Sir John Tenniel. 96pp. 5%₆ x 8¼. 0-486-27543-4

AMERICA'S LIGHTHOUSES: An Illustrated History, Francis Ross Holland. Profusely illustrated fact-filled survey of American lighthouses since 1716. Over 200 stations — East, Gulf, and West coasts, Great Lakes, Hawaii, Alaska, Puerto Rico, the Virgin Islands, and the Mississippi and St. Lawrence Rivers. 240pp. 8 x 10¾. 0-486-25576-X

AN ENCYCLOPEDIA OF THE VIOLIN, Alberto Bachmann. Translated by Frederick H. Martens. Introduction by Eugene Ysaye. First published in 1925, this renowned reference remains unsurpassed as a source of essential information, from construction and evolution to repertoire and technique. Includes a glossary and 73 illustrations. 496pp. 6⅛ x 9¼. 0-486-46618-3

ANIMALS: 1,419 Copyright-Free Illustrations of Mammals, Birds, Fish, Insects, etc., Selected by Jim Harter. Selected for its visual impact and ease of use, this outstanding collection of wood engravings presents over 1,000 species of animals in extremely lifelike poses. Includes mammals, birds, reptiles, amphibians, fish, insects, and other invertebrates. 284pp. 9 x 12. 0-486-23766-4

THE ANNALS, Tacitus. Translated by Alfred John Church and William Jackson Brodribb. This vital chronicle of Imperial Rome, written by the era's great historian, spans A.D. 14-68 and paints incisive psychological portraits of major figures, from Tiberius to Nero. 416pp. 5%₆ x 8¼. 0-486-45236-0

ANTIGONE, Sophocles. Filled with passionate speeches and sensitive probing of moral and philosophical issues, this powerful and often-performed Greek drama reveals the grim fate that befalls the children of Oedipus. Footnotes. 64pp. 5%₆ x 8 ¼. 0-486-27804-2

ART DECO DECORATIVE PATTERNS IN FULL COLOR, Christian Stoll. Reprinted from a rare 1910 portfolio, 160 sensuous and exotic images depict a breathtaking array of florals, geometrics, and abstracts — all elegant in their stark simplicity. 64pp. 8⅜ x 11. 0-486-44862-2

THE ARTHUR RACKHAM TREASURY: 86 Full-Color Illustrations, Arthur Rackham. Selected and Edited by Jeff A. Menges. A stunning treasury of 86 full-page plates span the famed English artist's career, from *Rip Van Winkle* (1905) to masterworks such as *Undine, A Midsummer Night's Dream,* and *Wind in the Willows* (1939). 96pp. 8⅜ x 11. 0-486-44685-9

THE AUTHENTIC GILBERT & SULLIVAN SONGBOOK, W. S. Gilbert and A. S. Sullivan. The most comprehensive collection available, this songbook includes selections from every one of Gilbert and Sullivan's light operas. Ninety-two numbers are presented uncut and unedited, and in their original keys. 410pp. 9 x 12. 0-486-23482-7

THE AWAKENING, Kate Chopin. First published in 1899, this controversial novel of a New Orleans wife's search for love outside a stifling marriage shocked readers. Today, it remains a first-rate narrative with superb characterization. New introductory Note. 128pp. 5%₆ x 8¼. 0-486-27786-0

BASIC DRAWING, Louis Priscilla. Beginning with perspective, this commonsense manual progresses to the figure in movement, light and shade, anatomy, drapery, composition, trees and landscape, and outdoor sketching. Black-and-white illustrations throughout. 128pp. 8⅜ x 11. 0-486-45815-6

Browse over 9,000 books at www.doverpublications.com

THE BATTLES THAT CHANGED HISTORY, Fletcher Pratt. Historian profiles 16 crucial conflicts, ancient to modern, that changed the course of Western civilization. Gripping accounts of battles led by Alexander the Great, Joan of Arc, Ulysses S. Grant, other commanders. 27 maps. 352pp. 5⅜ x 8½. 0-486-41129-X

BEETHOVEN'S LETTERS, Ludwig van Beethoven. Edited by Dr. A. C. Kalischer. Features 457 letters to fellow musicians, friends, greats, patrons, and literary men. Reveals musical thoughts, quirks of personality, insights, and daily events. Includes 15 plates. 410pp. 5⅜ x 8½. 0-486-22769-3

BERNICE BOBS HER HAIR AND OTHER STORIES, F. Scott Fitzgerald. This brilliant anthology includes 6 of Fitzgerald's most popular stories: "The Diamond as Big as the Ritz," the title tale, "The Offshore Pirate," "The Ice Palace," "The Jelly Bean," and "May Day." 176pp. 5⅜ x 8½. 0-486-47049-0

BESLER'S BOOK OF FLOWERS AND PLANTS: 73 Full-Color Plates from Hortus Eystettensis, 1613, Basilius Besler. Here is a selection of magnificent plates from the *Hortus Eystettensis,* which vividly illustrated and identified the plants, flowers, and trees that thrived in the legendary German garden at Eichstätt. 80pp. 8⅜ x 11.
0-486-46005-3

THE BOOK OF KELLS, Edited by Blanche Cirker. Painstakingly reproduced from a rare facsimile edition, this volume contains full-page decorations, portraits, illustrations, plus a sampling of textual leaves with exquisite calligraphy and ornamentation. 32 full-color illustrations. 32pp. 9⅜ x 12¼. 0-486-24345-1

THE BOOK OF THE CROSSBOW: With an Additional Section on Catapults and Other Siege Engines, Ralph Payne-Gallwey. Fascinating study traces history and use of crossbow as military and sporting weapon, from Middle Ages to modern times. Also covers related weapons: balistas, catapults, Turkish bows, more. Over 240 illustrations. 400pp. 7¼ x 10⅛. 0-486-28720-3

THE BUNGALOW BOOK: Floor Plans and Photos of 112 Houses, 1910, Henry L. Wilson. Here are 112 of the most popular and economic blueprints of the early 20th century — plus an illustration or photograph of each completed house. A wonderful time capsule that still offers a wealth of valuable insights. 160pp. 8⅜ x 11.
0-486-45104-6

THE CALL OF THE WILD, Jack London. A classic novel of adventure, drawn from London's own experiences as a Klondike adventurer, relating the story of a heroic dog caught in the brutal life of the Alaska Gold Rush. Note. 64pp. 5³⁄₁₆ x 8¼.
0-486-26472-6

CANDIDE, Voltaire. Edited by Francois-Marie Arouet. One of the world's great satires since its first publication in 1759. Witty, caustic skewering of romance, science, philosophy, religion, government — nearly all human ideals and institutions. 112pp. 5³⁄₁₆ x 8¼. 0-486-26689-3

CELEBRATED IN THEIR TIME: Photographic Portraits from the George Grantham Bain Collection, Edited by Amy Pastan. With an Introduction by Michael Carlebach. Remarkable portrait gallery features 112 rare images of Albert Einstein, Charlie Chaplin, the Wright Brothers, Henry Ford, and other luminaries from the worlds of politics, art, entertainment, and industry. 128pp. 8⅜ x 11. 0-486-46754-6

CHARIOTS FOR APOLLO: The NASA History of Manned Lunar Spacecraft to 1969, Courtney G. Brooks, James M. Grimwood, and Loyd S. Swenson, Jr. This illustrated history by a trio of experts is the definitive reference on the Apollo spacecraft and lunar modules. It traces the vehicles' design, development, and operation in space. More than 100 photographs and illustrations. 576pp. 6¾ x 9¼. 0-486-46756-2

A CHRISTMAS CAROL, Charles Dickens. This engrossing tale relates Ebenezer Scrooge's ghostly journeys through Christmases past, present, and future and his ultimate transformation from a harsh and grasping old miser to a charitable and compassionate human being. 80pp. 5³⁄₁₆ x 8¼. 0-486-26865-9

COMMON SENSE, Thomas Paine. First published in January of 1776, this highly influential landmark document clearly and persuasively argued for American separation from Great Britain and paved the way for the Declaration of Independence. 64pp. 5³⁄₁₆ x 8¼. 0-486-29602-4

THE COMPLETE SHORT STORIES OF OSCAR WILDE, Oscar Wilde. Complete texts of "The Happy Prince and Other Tales," "A House of Pomegranates," "Lord Arthur Savile's Crime and Other Stories," "Poems in Prose," and "The Portrait of Mr. W. H." 208pp. 5³⁄₁₆ x 8¼. 0-486-45216-6

COMPLETE SONNETS, William Shakespeare. Over 150 exquisite poems deal with love, friendship, the tyranny of time, beauty's evanescence, death, and other themes in language of remarkable power, precision, and beauty. Glossary of archaic terms. 80pp. 5³⁄₁₆ x 8¼. 0-486-26686-9

THE COUNT OF MONTE CRISTO: Abridged Edition, Alexandre Dumas. Falsely accused of treason, Edmond Dantès is imprisoned in the bleak Chateau d'If. After a hair-raising escape, he launches an elaborate plot to extract a bitter revenge against those who betrayed him. 448pp. 5³⁄₁₆ x 8¼. 0-486-45643-9

CRAFTSMAN BUNGALOWS: Designs from the Pacific Northwest, Yoho & Merritt. This reprint of a rare catalog, showcasing the charming simplicity and cozy style of Craftsman bungalows, is filled with photos of completed homes, plus floor plans and estimated costs. An indispensable resource for architects, historians, and illustrators. 112pp. 10 x 7. 0-486-46875-5

CRAFTSMAN BUNGALOWS: 59 Homes from "The Craftsman," Edited by Gustav Stickley. Best and most attractive designs from Arts and Crafts Movement publication — 1903–1916 — includes sketches, photographs of homes, floor plans, descriptive text. 128pp. 8¼ x 11. 0-486-25829-7

CRIME AND PUNISHMENT, Fyodor Dostoyevsky. Translated by Constance Garnett. Supreme masterpiece tells the story of Raskolnikov, a student tormented by his own thoughts after he murders an old woman. Overwhelmed by guilt and terror, he confesses and goes to prison. 480pp. 5³⁄₁₆ x 8¼. 0-486-41587-2

THE DECLARATION OF INDEPENDENCE AND OTHER GREAT DOCUMENTS OF AMERICAN HISTORY: 1775-1865, Edited by John Grafton. Thirteen compelling and influential documents: Henry's "Give Me Liberty or Give Me Death," Declaration of Independence, The Constitution, Washington's First Inaugural Address, The Monroe Doctrine, The Emancipation Proclamation, Gettysburg Address, more. 64pp. 5³⁄₁₆ x 8¼. 0-486-41124-9

THE DESERT AND THE SOWN: Travels in Palestine and Syria, Gertrude Bell. "The female Lawrence of Arabia," Gertrude Bell wrote captivating, perceptive accounts of her travels in the Middle East. This intriguing narrative, accompanied by 160 photos, traces her 1905 sojourn in Lebanon, Syria, and Palestine. 368pp. 5⅜ x 8½. 0-486-46876-3

A DOLL'S HOUSE, Henrik Ibsen. Ibsen's best-known play displays his genius for realistic prose drama. An expression of women's rights, the play climaxes when the central character, Nora, rejects a smothering marriage and life in "a doll's house." 80pp. 5³⁄₁₆ x 8¼. 0-486-27062-9

Browse over 9,000 books at www.doverpublications.com

DOOMED SHIPS: Great Ocean Liner Disasters, William H. Miller, Jr. Nearly 200 photographs, many from private collections, highlight tales of some of the vessels whose pleasure cruises ended in catastrophe: the *Morro Castle, Normandie, Andrea Doria, Europa,* and many others. 128pp. 8⅜ x 11¼. 0-486-45366-9

THE DORÉ BIBLE ILLUSTRATIONS, Gustave Doré. Detailed plates from the Bible: the Creation scenes, Adam and Eve, horrifying visions of the Flood, the battle sequences with their monumental crowds, depictions of the life of Jesus, 241 plates in all. 241pp. 9 x 12. 0-486-23004-X

DRAWING DRAPERY FROM HEAD TO TOE, Cliff Young. Expert guidance on how to draw shirts, pants, skirts, gloves, hats, and coats on the human figure, including folds in relation to the body, pull and crush, action folds, creases, more. Over 200 drawings. 48pp. 8¼ x 11. 0-486-45591-2

DUBLINERS, James Joyce. A fine and accessible introduction to the work of one of the 20th century's most influential writers, this collection features 15 tales, including a masterpiece of the short-story genre, "The Dead." 160pp. 5³⁄₁₆ x 8¼.
0-486-26870-5

EASY-TO-MAKE POP-UPS, Joan Irvine. Illustrated by Barbara Reid. Dozens of wonderful ideas for three-dimensional paper fun — from holiday greeting cards with moving parts to a pop-up menagerie. Easy-to-follow, illustrated instructions for more than 30 projects. 299 black-and-white illustrations. 96pp. 8⅜ x 11.
0-486-44622-0

EASY-TO-MAKE STORYBOOK DOLLS: A "Novel" Approach to Cloth Dollmaking, Sherralyn St. Clair. Favorite fictional characters come alive in this unique beginner's dollmaking guide. Includes patterns for Pollyanna, Dorothy from *The Wonderful Wizard of Oz,* Mary of *The Secret Garden,* plus easy-to-follow instructions, 263 black-and-white illustrations, and an 8-page color insert. 112pp. 8¼ x 11. 0-486-47360-0

EINSTEIN'S ESSAYS IN SCIENCE, Albert Einstein. Speeches and essays in accessible, everyday language profile influential physicists such as Niels Bohr and Isaac Newton. They also explore areas of physics to which the author made major contributions. 128pp. 5 x 8. 0-486-47011-3

EL DORADO: Further Adventures of the Scarlet Pimpernel, Baroness Orczy. A popular sequel to *The Scarlet Pimpernel,* this suspenseful story recounts the Pimpernel's attempts to rescue the Dauphin from imprisonment during the French Revolution. An irresistible blend of intrigue, period detail, and vibrant characterizations. 352pp. 5³⁄₁₆ x 8¼. 0-486-44026-5

ELEGANT SMALL HOMES OF THE TWENTIES: 99 Designs from a Competition, Chicago Tribune. Nearly 100 designs for five- and six-room houses feature New England and Southern colonials, Normandy cottages, stately Italianate dwellings, and other fascinating snapshots of American domestic architecture of the 1920s. 112pp. 9 x 12. 0-486-46910-7

THE ELEMENTS OF STYLE: The Original Edition, William Strunk, Jr. This is the book that generations of writers have relied upon for timeless advice on grammar, diction, syntax, and other essentials. In concise terms, it identifies the principal requirements of proper style and common errors. 64pp. 5⅜ x 8½. 0-486-44798-7

THE ELUSIVE PIMPERNEL, Baroness Orczy. Robespierre's revolutionaries find their wicked schemes thwarted by the heroic Pimpernel — Sir Percival Blakeney. In this thrilling sequel, Chauvelin devises a plot to eliminate the Pimpernel and his wife. 272pp. 5³⁄₁₆ x 8¼. 0-486-45464-9

AN ENCYCLOPEDIA OF BATTLES: Accounts of Over 1,560 Battles from 1479 B.C. to the Present, David Eggenberger. Essential details of every major battle in recorded history from the first battle of Megiddo in 1479 B.C. to Grenada in 1984. List of battle maps. 99 illustrations. 544pp. 6½ x 9¼. 0-486-24913-1

ENCYCLOPEDIA OF EMBROIDERY STITCHES, INCLUDING CREWEL, Marion Nichols. Precise explanations and instructions, clearly illustrated, on how to work chain, back, cross, knotted, woven stitches, and many more — 178 in all, including Cable Outline, Whipped Satin, and Eyelet Buttonhole. Over 1400 illustrations. 219pp. 8⅜ x 11¼. 0-486-22929-7

ENTER JEEVES: 15 Early Stories, P. G. Wodehouse. Splendid collection contains first 8 stories featuring Bertie Wooster, the deliciously dim aristocrat and Jeeves, his brainy, imperturbable manservant. Also, the complete Reggie Pepper (Bertie's prototype) series. 288pp. 5⅜ x 8½. 0-486-29717-9

ERIC SLOANE'S AMERICA: Paintings in Oil, Michael Wigley. With a Foreword by Mimi Sloane. Eric Sloane's evocative oils of America's landscape and material culture shimmer with immense historical and nostalgic appeal. This original hardcover collection gathers nearly a hundred of his finest paintings, with subjects ranging from New England to the American Southwest. 128pp. 10⅝ x 9.

0-486-46525-X

ETHAN FROME, Edith Wharton. Classic story of wasted lives, set against a bleak New England background. Superbly delineated characters in a hauntingly grim tale of thwarted love. Considered by many to be Wharton's masterpiece. 96pp. 5³⁄₁₆ x 8 ¼. 0-486-26690-7

THE EVERLASTING MAN, G. K. Chesterton. Chesterton's view of Christianity — as a blend of philosophy and mythology, satisfying intellect and spirit — applies to his brilliant book, which appeals to readers' heads as well as their hearts. 288pp. 5⅜ x 8½. 0-486-46036-3

THE FIELD AND FOREST HANDY BOOK, Daniel Beard. Written by a co-founder of the Boy Scouts, this appealing guide offers illustrated instructions for building kites, birdhouses, boats, igloos, and other fun projects, plus numerous helpful tips for campers. 448pp. 5³⁄₁₆ x 8¼. 0-486-46191-2

FINDING YOUR WAY WITHOUT MAP OR COMPASS, Harold Gatty. Useful, instructive manual shows would-be explorers, hikers, bikers, scouts, sailors, and survivalists how to find their way outdoors by observing animals, weather patterns, shifting sands, and other elements of nature. 288pp. 5⅜ x 8½. 0-486-40613-X

FIRST FRENCH READER: A Beginner's Dual-Language Book, Edited and Translated by Stanley Appelbaum. This anthology introduces 50 legendary writers — Voltaire, Balzac, Baudelaire, Proust, more — through passages from *The Red and the Black, Les Misérables, Madame Bovary*, and other classics. Original French text plus English translation on facing pages. 240pp. 5⅜ x 8½. 0-486-46178-5

FIRST GERMAN READER: A Beginner's Dual-Language Book, Edited by Harry Steinhauer. Specially chosen for their power to evoke German life and culture, these short, simple readings include poems, stories, essays, and anecdotes by Goethe, Hesse, Heine, Schiller, and others. 224pp. 5⅜ x 8½. 0-486-46179-3

FIRST SPANISH READER: A Beginner's Dual-Language Book, Angel Flores. Delightful stories, other material based on works of Don Juan Manuel, Luis Taboada, Ricardo Palma, other noted writers. Complete faithful English translations on facing pages. Exercises. 176pp. 5⅜ x 8½. 0-486-25810-6

FIVE ACRES AND INDEPENDENCE, Maurice G. Kains. Great back-to-the-land classic explains basics of self-sufficient farming. The one book to get. 95 illustrations. 397pp. 5⅜ x 8½. 0-486-20974-1

FLAGG'S SMALL HOUSES: Their Economic Design and Construction, 1922, Ernest Flagg. Although most famous for his skyscrapers, Flagg was also a proponent of the well-designed single-family dwelling. His classic treatise features innovations that save space, materials, and cost. 526 illustrations. 160pp. 9⅜ x 12¼.
0-486-45197-6

FLATLAND: A Romance of Many Dimensions, Edwin A. Abbott. Classic of science (and mathematical) fiction — charmingly illustrated by the author — describes the adventures of A. Square, a resident of Flatland, in Spaceland (three dimensions), Lineland (one dimension), and Pointland (no dimensions). 96pp. 5³⁄₁₆ x 8¼.
0-486-27263-X

FRANKENSTEIN, Mary Shelley. The story of Victor Frankenstein's monstrous creation and the havoc it caused has enthralled generations of readers and inspired countless writers of horror and suspense. With the author's own 1831 introduction. 176pp. 5³⁄₁₆ x 8¼. 0-486-28211-2

THE GARGOYLE BOOK: 572 Examples from Gothic Architecture, Lester Burbank Bridaham. Dispelling the conventional wisdom that French Gothic architectural flourishes were born of despair or gloom, Bridaham reveals the whimsical nature of these creations and the ingenious artisans who made them. 572 illustrations. 224pp. 8⅜ x 11. 0-486-44754-5

THE GIFT OF THE MAGI AND OTHER SHORT STORIES, O. Henry. Sixteen captivating stories by one of America's most popular storytellers. Included are such classics as "The Gift of the Magi," "The Last Leaf," and "The Ransom of Red Chief." Publisher's Note. 96pp. 5³⁄₁₆ x 8¼. 0-486-27061-0

THE GOETHE TREASURY: Selected Prose and Poetry, Johann Wolfgang von Goethe. Edited, Selected, and with an Introduction by Thomas Mann. In addition to his lyric poetry, Goethe wrote travel sketches, autobiographical studies, essays, letters, and proverbs in rhyme and prose. This collection presents outstanding examples from each genre. 368pp. 5⅜ x 8½. 0-486-44780-4

GREAT EXPECTATIONS, Charles Dickens. Orphaned Pip is apprenticed to the dirty work of the forge but dreams of becoming a gentleman — and one day finds himself in possession of "great expectations." Dickens' finest novel. 400pp. 5³⁄₁₆ x 8¼.
0-486-41586-4

GREAT WRITERS ON THE ART OF FICTION: From Mark Twain to Joyce Carol Oates, Edited by James Daley. An indispensable source of advice and inspiration, this anthology features essays by Henry James, Kate Chopin, Willa Cather, Sinclair Lewis, Jack London, Raymond Chandler, Raymond Carver, Eudora Welty, and Kurt Vonnegut, Jr. 192pp. 5⅜ x 8½. 0-486-45128-3

HAMLET, William Shakespeare. The quintessential Shakespearean tragedy, whose highly charged confrontations and anguished soliloquies probe depths of human feeling rarely sounded in any art. Reprinted from an authoritative British edition complete with illuminating footnotes. 128pp. 5³⁄₁₆ x 8¼. 0-486-27278-8

THE HAUNTED HOUSE, Charles Dickens. A Yuletide gathering in an eerie country retreat provides the backdrop for Dickens and his friends — including Elizabeth Gaskell and Wilkie Collins — who take turns spinning supernatural yarns. 144pp. 5⅜ x 8½. 0-486-46309-5

Browse over 9,000 books at www.doverpublications.com

HEART OF DARKNESS, Joseph Conrad. Dark allegory of a journey up the Congo River and the narrator's encounter with the mysterious Mr. Kurtz. Masterly blend of adventure, character study, psychological penetration. For many, Conrad's finest, most enigmatic story. 80pp. 5³⁄₁₆ x 8¼. 0-486-26464-5

HENSON AT THE NORTH POLE, Matthew A. Henson. This thrilling memoir by the heroic African-American who was Peary's companion through two decades of Arctic exploration recounts a tale of danger, courage, and determination. "Fascinating and exciting." — *Commonweal*. 128pp. 5⅜ x 8½. 0-486-45472-X

HISTORIC COSTUMES AND HOW TO MAKE THEM, Mary Fernald and E. Shenton. Practical, informative guidebook shows how to create everything from short tunics worn by Saxon men in the fifth century to a lady's bustle dress of the late 1800s. 81 illustrations. 176pp. 5⅜ x 8½. 0-486-44906-8

THE HOUND OF THE BASKERVILLES, Arthur Conan Doyle. A deadly curse in the form of a legendary ferocious beast continues to claim its victims from the Baskerville family until Holmes and Watson intervene. Often called the best detective story ever written. 128pp. 5³⁄₁₆ x 8¼. 0-486-28214-7

THE HOUSE BEHIND THE CEDARS, Charles W. Chesnutt. Originally published in 1900, this groundbreaking novel by a distinguished African-American author recounts the drama of a brother and sister who "pass for white" during the dangerous days of Reconstruction. 208pp. 5⅜ x 8½. 0-486-46144-0

THE HUMAN FIGURE IN MOTION, Eadweard Muybridge. The 4,789 photographs in this definitive selection show the human figure — models almost all undraped — engaged in over 160 different types of action: running, climbing stairs, etc. 390pp. 7⅞ x 10⅝. 0-486-20204-6

THE IMPORTANCE OF BEING EARNEST, Oscar Wilde. Wilde's witty and buoyant comedy of manners, filled with some of literature's most famous epigrams, reprinted from an authoritative British edition. Considered Wilde's most perfect work. 64pp. 5³⁄₁₆ x 8¼. 0-486-26478-5

THE INFERNO, Dante Alighieri. Translated and with notes by Henry Wadsworth Longfellow. The first stop on Dante's famous journey from Hell to Purgatory to Paradise, this 14th-century allegorical poem blends vivid and shocking imagery with graceful lyricism. Translated by the beloved 19th-century poet, Henry Wadsworth Longfellow. 256pp. 5³⁄₁₆ x 8¼. 0-486-44288-8

JANE EYRE, Charlotte Brontë. Written in 1847, *Jane Eyre* tells the tale of an orphan girl's progress from the custody of cruel relatives to an oppressive boarding school and its culmination in a troubled career as a governess. 448pp. 5³⁄₁₆ x 8¼.
 0-486-42449-9

JAPANESE WOODBLOCK FLOWER PRINTS, Tanigami Kônan. Extraordinary collection of Japanese woodblock prints by a well-known artist features 120 plates in brilliant color. Realistic images from a rare edition include daffodils, tulips, and other familiar and unusual flowers. 128pp. 11 x 8¼. 0-486-46442-3

JEWELRY MAKING AND DESIGN, Augustus F. Rose and Antonio Cirino. Professional secrets of jewelry making are revealed in a thorough, practical guide. Over 200 illustrations. 306pp. 5⅜ x 8½. 0-486-21750-7

JULIUS CAESAR, William Shakespeare. Great tragedy based on Plutarch's account of the lives of Brutus, Julius Caesar and Mark Antony. Evil plotting, ringing oratory, high tragedy with Shakespeare's incomparable insight, dramatic power. Explanatory footnotes. 96pp. 5³⁄₁₆ x 8¼. 0-486-26876-4

THE JUNGLE, Upton Sinclair. 1906 bestseller shockingly reveals intolerable labor practices and working conditions in the Chicago stockyards as it tells the grim story of a Slavic family that emigrates to America full of optimism but soon faces despair. 320pp. 5³⁄₁₆ x 8¼. 0-486-41923-1

THE KINGDOM OF GOD IS WITHIN YOU, Leo Tolstoy. The soul-searching book that inspired Gandhi to embrace the concept of passive resistance, Tolstoy's 1894 polemic clearly outlines a radical, well-reasoned revision of traditional Christian thinking. 352pp. 5³⁄₁₆ x 8¼. 0-486-45138-0

THE LADY OR THE TIGER?: and Other Logic Puzzles, Raymond M. Smullyan. Created by a renowned puzzle master, these whimsically themed challenges involve paradoxes about probability, time, and change; metapuzzles; and self-referentiality. Nineteen chapters advance in difficulty from relatively simple to highly complex. 1982 edition. 240pp. 5⅜ x 8½. 0-486-47027-X

LEAVES OF GRASS: The Original 1855 Edition, Walt Whitman. Whitman's immortal collection includes some of the greatest poems of modern times, including his masterpiece, "Song of Myself." Shattering standard conventions, it stands as an unabashed celebration of body and nature. 128pp. 5³⁄₁₆ x 8¼. 0-486-45676-5

LES MISÉRABLES, Victor Hugo. Translated by Charles E. Wilbour. Abridged by James K. Robinson. A convict's heroic struggle for justice and redemption plays out against a fiery backdrop of the Napoleonic wars. This edition features the excellent original translation and a sensitive abridgment. 304pp. 6⅛ x 9¼.
0-486-45789-3

LILITH: A Romance, George MacDonald. In this novel by the father of fantasy literature, a man travels through time to meet Adam and Eve and to explore humanity's fall from grace and ultimate redemption. 240pp. 5⅜ x 8½.
0-486-46818-6

THE LOST LANGUAGE OF SYMBOLISM, Harold Bayley. This remarkable book reveals the hidden meaning behind familiar images and words, from the origins of Santa Claus to the fleur-de-lys, drawing from mythology, folklore, religious texts, and fairy tales. 1,418 illustrations. 784pp. 5⅜ x 8½. 0-486-44787-1

MACBETH, William Shakespeare. A Scottish nobleman murders the king in order to succeed to the throne. Tortured by his conscience and fearful of discovery, he becomes tangled in a web of treachery and deceit that ultimately spells his doom. 96pp. 5³⁄₁₆ x 8¼. 0-486-27802-6

MAKING AUTHENTIC CRAFTSMAN FURNITURE: Instructions and Plans for 62 Projects, Gustav Stickley. Make authentic reproductions of handsome, functional, durable furniture: tables, chairs, wall cabinets, desks, a hall tree, and more. Construction plans with drawings, schematics, dimensions, and lumber specs reprinted from 1900s *The Craftsman* magazine. 128pp. 8¼ x 11. 0-486-25000-8

MATHEMATICS FOR THE NONMATHEMATICIAN, Morris Kline. Erudite and entertaining overview follows development of mathematics from ancient Greeks to present. Topics include logic and mathematics, the fundamental concept, differential calculus, probability theory, much more. Exercises and problems. 641pp. 5⅜ x 8½. 0-486-24823-2

MEMOIRS OF AN ARABIAN PRINCESS FROM ZANZIBAR, Emily Ruete. This 19th-century autobiography offers a rare inside look at the society surrounding a sultan's palace. A real-life princess in exile recalls her vanished world of harems, slave trading, and court intrigues. 288pp. 5⅜ x 8½. 0-486-47121-7

THE METAMORPHOSIS AND OTHER STORIES, Franz Kafka. Excellent new English translations of title story (considered by many critics Kafka's most perfect work), plus "The Judgment," "In the Penal Colony," "A Country Doctor," and "A Report to an Academy." Note. 96pp. 5³⁄₁₆ x 8¼. 0-486-29030-1

MICROSCOPIC ART FORMS FROM THE PLANT WORLD, R. Anheisser. From undulating curves to complex geometrics, a world of fascinating images abound in this classic, illustrated survey of microscopic plants. Features 400 detailed illustrations of nature's minute but magnificent handiwork. The accompanying CD-ROM includes all of the images in the book. 128pp. 9 x 9. 0-486-46013-4

A MIDSUMMER NIGHT'S DREAM, William Shakespeare. Among the most popular of Shakespeare's comedies, this enchanting play humorously celebrates the vagaries of love as it focuses upon the intertwined romances of several pairs of lovers. Explanatory footnotes. 80pp. 5³⁄₁₆ x 8¼. 0-486-27067-X

THE MONEY CHANGERS, Upton Sinclair. Originally published in 1908, this cautionary novel from the author of *The Jungle* explores corruption within the American system as a group of power brokers joins forces for personal gain, triggering a crash on Wall Street. 192pp. 5⅜ x 8½. 0-486-46917-4

THE MOST POPULAR HOMES OF THE TWENTIES, William A. Radford. With a New Introduction by Daniel D. Reiff. Based on a rare 1925 catalog, this architectural showcase features floor plans, construction details, and photos of 26 homes, plus articles on entrances, porches, garages, and more. 250 illustrations, 21 color plates. 176pp. 8⅜ x 11. 0-486-47028-8

MY 66 YEARS IN THE BIG LEAGUES, Connie Mack. With a New Introduction by Rich Westcott. A Founding Father of modern baseball, Mack holds the record for most wins — and losses — by a major league manager. Enhanced by 70 photographs, his warmhearted autobiography is populated by many legends of the game. 288pp. 5⅜ x 8½. 0-486-47184-5

NARRATIVE OF THE LIFE OF FREDERICK DOUGLASS, Frederick Douglass. Douglass's graphic depictions of slavery, harrowing escape to freedom, and life as a newspaper editor, eloquent orator, and impassioned abolitionist. 96pp. 5³⁄₁₆ x 8¼. 0-486-28499-9

THE NIGHTLESS CITY: Geisha and Courtesan Life in Old Tokyo, J. E. de Becker. This unsurpassed study from 100 years ago ventured into Tokyo's red-light district to survey geisha and courtesan life and offer meticulous descriptions of training, dress, social hierarchy, and erotic practices. 49 black-and-white illustrations; 2 maps. 496pp. 5⅜ x 8½. 0-486-45563-7

THE ODYSSEY, Homer. Excellent prose translation of ancient epic recounts adventures of the homeward-bound Odysseus. Fantastic cast of gods, giants, cannibals, sirens, other supernatural creatures — true classic of Western literature. 256pp. 5³⁄₁₆ x 8¼. 0-486-40654-7

OEDIPUS REX, Sophocles. Landmark of Western drama concerns the catastrophe that ensues when King Oedipus discovers he has inadvertently killed his father and married his mother. Masterly construction, dramatic irony. Explanatory footnotes. 64pp. 5³⁄₁₆ x 8¼. 0-486-26877-2

ONCE UPON A TIME: The Way America Was, Eric Sloane. Nostalgic text and drawings brim with gentle philosophies and descriptions of how we used to live — self-sufficiently — on the land, in homes, and among the things built by hand. 44 line illustrations. 64pp. 8⅜ x 11. 0-486-44411-2

ONE OF OURS, Willa Cather. The Pulitzer Prize–winning novel about a young Nebraskan looking for something to believe in. Alienated from his parents, rejected by his wife, he finds his destiny on the bloody battlefields of World War I. 352pp. 5³⁄₁₆ x 8¼. 0-486-45599-8

ORIGAMI YOU CAN USE: 27 Practical Projects, Rick Beech. Origami models can be more than decorative, and this unique volume shows how! The 27 practical projects include a CD case, frame, napkin ring, and dish. Easy instructions feature 400 two-color illustrations. 96pp. 8¼ x 11. 0-486-47057-1

OTHELLO, William Shakespeare. Towering tragedy tells the story of a Moorish general who earns the enmity of his ensign Iago when he passes him over for a promotion. Masterly portrait of an archvillain. Explanatory footnotes. 112pp. 5³⁄₁₆ x 8¼. 0-486-29097-2

PARADISE LOST, John Milton. Notes by John A. Himes. First published in 1667, *Paradise Lost* ranks among the greatest of English literature's epic poems. It's a sublime retelling of Adam and Eve's fall from grace and expulsion from Eden. Notes by John A. Himes. 480pp. 5³⁄₁₆ x 8¼. 0-486-44287-X

PASSING, Nella Larsen. Married to a successful physician and prominently ensconced in society, Irene Redfield leads a charmed existence — until a chance encounter with a childhood friend who has been "passing for white." 112pp. 5⅜ x 8½. 0-486-43713-2

PERSPECTIVE DRAWING FOR BEGINNERS, Len A. Doust. Doust carefully explains the roles of lines, boxes, and circles, and shows how visualizing shapes and forms can be used in accurate depictions of perspective. One of the most concise introductions available. 33 illustrations. 64pp. 5⅜ x 8½. 0-486-45149-6

PERSPECTIVE MADE EASY, Ernest R. Norling. Perspective is easy; yet, surprisingly few artists know the simple rules that make it so. Remedy that situation with this simple, step-by-step book, the first devoted entirely to the topic. 256 illustrations. 224pp. 5⅜ x 8½. 0-486-40473-0

THE PICTURE OF DORIAN GRAY, Oscar Wilde. Celebrated novel involves a handsome young Londoner who sinks into a life of depravity. His body retains perfect youth and vigor while his recent portrait reflects the ravages of his crime and sensuality. 176pp. 5³⁄₁₆ x 8¼. 0-486-27807-7

PRIDE AND PREJUDICE, Jane Austen. One of the most universally loved and admired English novels, an effervescent tale of rural romance transformed by Jane Austen's art into a witty, shrewdly observed satire of English country life. 272pp. 5³⁄₁₆ x 8¼. 0-486-28473-5

THE PRINCE, Niccolò Machiavelli. Classic, Renaissance-era guide to acquiring and maintaining political power. Today, nearly 500 years after it was written, this calculating prescription for autocratic rule continues to be much read and studied. 80pp. 5³⁄₁₆ x 8¼. 0-486-27274-5

QUICK SKETCHING, Carl Cheek. A perfect introduction to the technique of "quick sketching." Drawing upon an artist's immediate emotional responses, this is an extremely effective means of capturing the essential form and features of a subject. More than 100 black-and-white illustrations throughout. 48pp. 11 x 8¼. 0-486-46608-6

RANCH LIFE AND THE HUNTING TRAIL, Theodore Roosevelt. Illustrated by Frederic Remington. Beautifully illustrated by Remington, Roosevelt's celebration of the Old West recounts his adventures in the Dakota Badlands of the 1880s, from roundups to Indian encounters to hunting bighorn sheep. 208pp. 6¼ x 9¼. 0-486-47340-6

THE RED BADGE OF COURAGE, Stephen Crane. Amid the nightmarish chaos of a Civil War battle, a young soldier discovers courage, humility, and, perhaps, wisdom. Uncanny re-creation of actual combat. Enduring landmark of American fiction. 112pp. 5³⁄₁₆ x 8¼. 0-486-26465-3

RELATIVITY SIMPLY EXPLAINED, Martin Gardner. One of the subject's clearest, most entertaining introductions offers lucid explanations of special and general theories of relativity, gravity, and spacetime, models of the universe, and more. 100 illustrations. 224pp. 5⅜ x 8½. 0-486-29315-7

REMBRANDT DRAWINGS: 116 Masterpieces in Original Color, Rembrandt van Rijn. This deluxe hardcover edition features drawings from throughout the Dutch master's prolific career. Informative captions accompany these beautifully reproduced landscapes, biblical vignettes, figure studies, animal sketches, and portraits. 128pp. 8⅜ x 11. 0-486-46149-1

THE ROAD NOT TAKEN AND OTHER POEMS, Robert Frost. A treasury of Frost's most expressive verse. In addition to the title poem: "An Old Man's Winter Night," "In the Home Stretch," "Meeting and Passing," "Putting in the Seed," many more. All complete and unabridged. 64pp. 5³⁄₁₆ x 8¼. 0-486-27550-7

ROMEO AND JULIET, William Shakespeare. Tragic tale of star-crossed lovers, feuding families and timeless passion contains some of Shakespeare's most beautiful and lyrical love poetry. Complete, unabridged text with explanatory footnotes. 96pp. 5³⁄₁₆ x 8¼. 0-486-27557-4

SANDITON AND THE WATSONS: Austen's Unfinished Novels, Jane Austen. Two tantalizing incomplete stories revisit Austen's customary milieu of courtship and venture into new territory, amid guests at a seaside resort. Both are worth reading for pleasure and study. 112pp. 5⅜ x 8½. 0-486-45793-1

THE SCARLET LETTER, Nathaniel Hawthorne. With stark power and emotional depth, Hawthorne's masterpiece explores sin, guilt, and redemption in a story of adultery in the early days of the Massachusetts Colony. 192pp. 5³⁄₁₆ x 8¼.
 0-486-28048-9

THE SEASONS OF AMERICA PAST, Eric Sloane. Seventy-five illustrations depict cider mills and presses, sleds, pumps, stump-pulling equipment, plows, and other elements of America's rural heritage. A section of old recipes and household hints adds additional color. 160pp. 8⅜ x 11. 0-486-44220-9

SELECTED CANTERBURY TALES, Geoffrey Chaucer. Delightful collection includes the General Prologue plus three of the most popular tales: "The Knight's Tale," "The Miller's Prologue and Tale," and "The Wife of Bath's Prologue and Tale." In modern English. 144pp. 5³⁄₁₆ x 8¼. 0-486-28241-4

SELECTED POEMS, Emily Dickinson. Over 100 best-known, best-loved poems by one of America's foremost poets, reprinted from authoritative early editions. No comparable edition at this price. Index of first lines. 64pp. 5³⁄₁₆ x 8¼. 0-486-26466-1

SIDDHARTHA, Hermann Hesse. Classic novel that has inspired generations of seekers. Blending Eastern mysticism and psychoanalysis, Hesse presents a strikingly original view of man and culture and the arduous process of self-discovery, reconciliation, harmony, and peace. 112pp. 5³⁄₁₆ x 8¼. 0-486-40653-9

SKETCHING OUTDOORS, Leonard Richmond. This guide offers beginners step-by-step demonstrations of how to depict clouds, trees, buildings, and other outdoor sights. Explanations of a variety of techniques include shading and constructional drawing. 48pp. 11 x 8¼. 0-486-46922-0

Browse over 9,000 books at www.doverpublications.com

SMALL HOUSES OF THE FORTIES: With Illustrations and Floor Plans, Harold E. Group. 56 floor plans and elevations of houses that originally cost less than $15,000 to build. Recommended by financial institutions of the era, they range from Colonials to Cape Cods. 144pp. 8⅜ x 11. 0-486-45598-X

SOME CHINESE GHOSTS, Lafcadio Hearn. Rooted in ancient Chinese legends, these richly atmospheric supernatural tales are recounted by an expert in Oriental lore. Their originality, power, and literary charm will captivate readers of all ages. 96pp. 5⅜ x 8½. 0-486-46306-0

SONGS FOR THE OPEN ROAD: Poems of Travel and Adventure, Edited by The American Poetry & Literacy Project. More than 80 poems by 50 American and British masters celebrate real and metaphorical journeys. Poems by Whitman, Byron, Millay, Sandburg, Langston Hughes, Emily Dickinson, Robert Frost, Shelley, Tennyson, Yeats, many others. Note. 80pp. 5³⁄₁₆ x 8¼. 0-486-40646-6

SPOON RIVER ANTHOLOGY, Edgar Lee Masters. An American poetry classic, in which former citizens of a mythical midwestern town speak touchingly from the grave of the thwarted hopes and dreams of their lives. 144pp. 5³⁄₁₆ x 8¼.
0-486-27275-3

STAR LORE: Myths, Legends, and Facts, William Tyler Olcott. Captivating retellings of the origins and histories of ancient star groups include Pegasus, Ursa Major, Pleiades, signs of the zodiac, and other constellations. "Classic." — *Sky & Telescope*. 58 illustrations. 544pp. 5⅜ x 8½. 0-486-43581-4

THE STRANGE CASE OF DR. JEKYLL AND MR. HYDE, Robert Louis Stevenson. This intriguing novel, both fantasy thriller and moral allegory, depicts the struggle of two opposing personalities — one essentially good, the other evil — for the soul of one man. 64pp. 5³⁄₁₆ x 8¼. 0-486-26688-5

SURVIVAL HANDBOOK: The Official U.S. Army Guide, Department of the Army. This special edition of the Army field manual is geared toward civilians. An essential companion for campers and all lovers of the outdoors, it constitutes the most authoritative wilderness guide. 288pp. 5³⁄₁₆ x 8¼. 0-486-46184-X

A TALE OF TWO CITIES, Charles Dickens. Against the backdrop of the French Revolution, Dickens unfolds his masterpiece of drama, adventure, and romance about a man falsely accused of treason. Excitement and derring-do in the shadow of the guillotine. 304pp. 5³⁄₁₆ x 8¼. 0-486-40651-2

TEN PLAYS, Anton Chekhov. *The Sea Gull, Uncle Vanya, The Three Sisters, The Cherry Orchard*, and *Ivanov*, plus 5 one-act comedies: *The Anniversary, An Unwilling Martyr, The Wedding, The Bear*, and *The Proposal*. 336pp. 5³⁄₁₆ x 8¼. 0-486-46560-8

THE FLYING INN, G. K. Chesterton. Hilarious romp in which pub owner Humphrey Hump and friend take to the road in a donkey cart filled with rum and cheese, inveighing against Prohibition and other "oppressive forms of modernity." 320pp. 5⅜ x 8½. 0-486-41910-X

THIRTY YEARS THAT SHOOK PHYSICS: The Story of Quantum Theory, George Gamow. Lucid, accessible introduction to the influential theory of energy and matter features careful explanations of Dirac's anti-particles, Bohr's model of the atom, and much more. Numerous drawings. 1966 edition. 240pp. 5⅜ x 8½. 0-486-24895-X

TREASURE ISLAND, Robert Louis Stevenson. Classic adventure story of a perilous sea journey, a mutiny led by the infamous Long John Silver, and a lethal scramble for buried treasure — seen through the eyes of cabin boy Jim Hawkins. 160pp. 5³⁄₁₆ x 8¼.
0-486-27559-0

THE TRIAL, Franz Kafka. Translated by David Wyllie. From its gripping first sentence onward, this novel exemplifies the term "Kafkaesque." Its darkly humorous narrative recounts a bank clerk's entrapment in a bureaucratic maze, based on an undisclosed charge. 176pp. 5⅜ x 8¼. 0-486-47061-X

THE TURN OF THE SCREW, Henry James. Gripping ghost story by great novelist depicts the sinister transformation of 2 innocent children into flagrant liars and hypocrites. An elegantly told tale of unspoken horror and psychological terror. 96pp. 5⅜ x 8¼. 0-486-26684-2

UP FROM SLAVERY, Booker T. Washington. Washington (1856-1915) rose to become the most influential spokesman for African-Americans of his day. In this eloquently written book, he describes events in a remarkable life that began in bondage and culminated in worldwide recognition. 160pp. 5⅜ x 8¼. 0-486-28738-6

VICTORIAN HOUSE DESIGNS IN AUTHENTIC FULL COLOR: 75 Plates from the "Scientific American – Architects and Builders Edition," 1885-1894, Edited by Blanche Cirker. Exquisitely detailed, exceptionally handsome designs for an enormous variety of attractive city dwellings, spacious suburban and country homes, charming "cottages" and other structures — all accompanied by perspective views and floor plans. 80pp. 9¼ x 12¼. 0-486-29438-2

VILLETTE, Charlotte Brontë. Acclaimed by Virginia Woolf as "Brontë's finest novel," this moving psychological study features a remarkably modern heroine who abandons her native England for a new life as a schoolteacher in Belgium. 480pp. 5⅜ x 8¼. 0-486-45557-2

THE VOYAGE OUT, Virginia Woolf. A moving depiction of the thrills and confusion of youth, Woolf's acclaimed first novel traces a shipboard journey to South America for a captivating exploration of a woman's growing self-awareness. 288pp. 5⅜ x 8¼. 0-486-45005-8

WALDEN; OR, LIFE IN THE WOODS, Henry David Thoreau. Accounts of Thoreau's daily life on the shores of Walden Pond outside Concord, Massachusetts, are interwoven with musings on the virtues of self-reliance and individual freedom, on society, government, and other topics. 224pp. 5⅜ x 8¼. 0-486-28495-6

WILD PILGRIMAGE: A Novel in Woodcuts, Lynd Ward. Through startling engravings shaded in black and red, Ward wordlessly tells the story of a man trapped in an industrial world, struggling between the grim reality around him and the fantasies his imagination creates. 112pp. 6⅛ x 9¼. 0-486-46583-7

WILLY POGÁNY REDISCOVERED, Willy Pogány. Selected and Edited by Jeff A. Menges. More than 100 color and black-and-white Art Nouveau–style illustrations from fairy tales and adventure stories include scenes from Wagner's "Ring" cycle, *The Rime of the Ancient Mariner, Gulliver's Travels*, and *Faust*. 144pp. 8⅜ x 11.
 0-486-47046-6

WOOLLY THOUGHTS: Unlock Your Creative Genius with Modular Knitting, Pat Ashforth and Steve Plummer. Here's the revolutionary way to knit — easy, fun, and foolproof! Beginners and experienced knitters need only master a single stitch to create their own designs with patchwork squares. More than 100 illustrations. 128pp. 6½ x 9¼. 0-486-46084-3

WUTHERING HEIGHTS, Emily Brontë. Somber tale of consuming passions and vengeance — played out amid the lonely English moors — recounts the turbulent and tempestuous love story of Cathy and Heathcliff. Poignant and compelling. 256pp. 5⅜ x 8¼. 0-486-29256-8

Browse over 9,000 books at www.doverpublications.com